PACKAGING:
A CULTURAL SIGN

In the local supermarkets one gets not only aware of eating habits and flavour preferences. What products are on offer and how much variety and competition is there? Also the choice in the different categories and the mix of international and local brands tells something about consumption patterns. Which adaptations make global brands in a local market? What tell local brands about the history of a country? The different designs, i.e. the use of typography, pictures, symbols and colours give one insight in the culture of a country and its trends. Packaging design is not only the mirror of the soul of a brand, but also of its users.

Packaging doesn't conceal but rather reveals a country's culture. The supermarket is the ideal territory for discovering a country's culture. It gives insight into the stomach and head of the different nations. In this book the culture of totally different countries from all continents are presented by day to day products, all available in the local supermarket. The author travelled around the world and made a personal selection, which attracts his attention. Not only the latest newest designs were selected, but also characteristic long lasting packaging designs. Together they tell the story of a country. Packaging is a cultural sign.

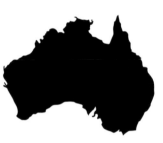

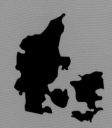

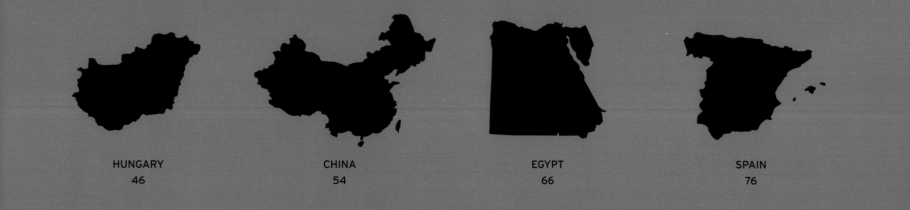

HUNGARY
46

CHINA
54

EGYPT
66

SPAIN
76

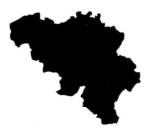

BELGIUM
124

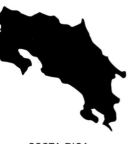

COSTA RICA
134

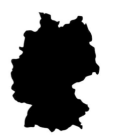

GERMANY
142

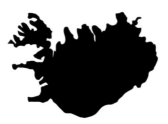

ICELAND
152

BRAZIL
206

USA
216

japan

SIMPLICITY AND INNOVATION

Tokyo city is a true Mecca for packaging designers. The Japanese have a long tradition of packaging. In Japan, an object is treated as though it has its own soul. The reverence that is afforded to the packaging shows respect. Everything is done carefully and everywhere you go perfection is the goal. The greengrocery sections of department stores stock melons intended as gift items. Depending on the perfection of each round form, the price can easily reach 75 euros. They are an eminently acceptable gift to take when you visit someone. In the cake and pastry department, a block of frozen nitrogen is quickly added to cakes before they are cocooned in layer upon layer of paper, ribbons, boxes, stickers and carrier bags. Then the assistant walks round the counter to the customer and presents the package using both hands and to the accompaniment of deep bows and expressions of thanks. As you continue with your shopping, you leave a smoky trail of evaporating nitrogen behind you. This too is a nice, and in this case chilled, gift you can be proud to present. But besides this tradition of and reverence for packaging, the Japanese are also open to innovation in the area of product development, design and technology. Next to the refrigerated shelves in the supermarket is a "hot" shelf with bottles of hot coffee and green tea. Well, why ever not?

This combination of care and originality produces the most beautiful packaging. New forms and use of material catch the attention. The tactile value of tins and bottles, as well as ordinary plastic or foil bags, is

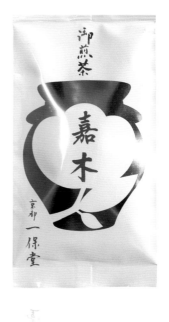

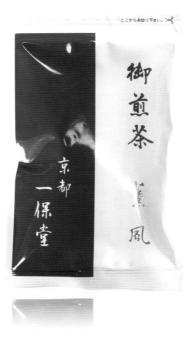

not forgotten. The bag of milk sweets, the richer the better, feels creamy to the touch. Traditionally crafted paper turns out to have been applied to airtight foil. Every time you are compelled to look at an existing product in a new light. And then there's the graphic design! Simplicity and purity abound. It seems that the brand managers here are well able to make clear choices in what they communicate. No conflicting messages vying for the customer's attention, the message is always clear. And of course we mustn't forget the multitude of cartoon characters. The Japanese are crazy about them. Characters are used in every category, up to and including the famous sake. Laughing and winking, they greet you at every turn. It's one big party. Shop 'til you drop.

1. CLASSIC TEA
There is an abundance of tea packaging. From the very traditional with delicate folded and decorated paper up to and including modern foil with minimalist print.

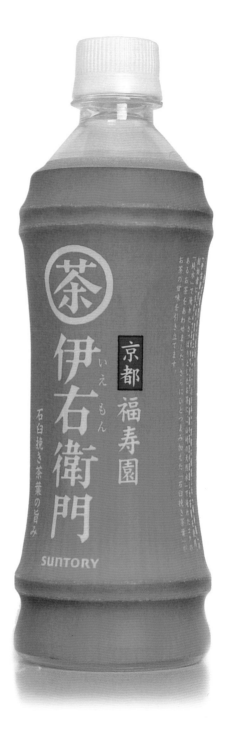

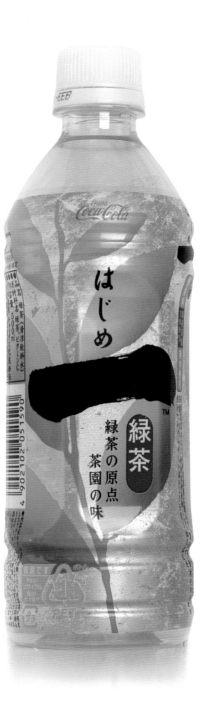

2. BOTTLES OF GREEN TEA

Green tea is drunk everywhere and all the time.
Even chilled from a PET bottle. For example, in the
shape of a bamboo stem from Suntory. This earned
a Japan Package Design Golden Award for creator
Kato Yoshio. Rival Coca-Cola, also has a version that
is 100% Japanese.

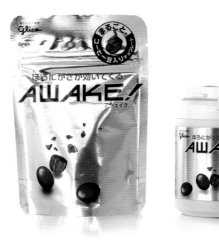

3. AWAKE!

What's in a name: Awake! A coffee bean wrapped in chocolate for a shot of caffeine. Cleanly designed in different packaging forms.

4. CREAM CANDIES

Completely coated in cream. Just the thing to make your mouth water.

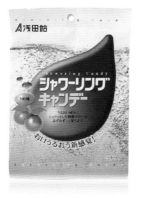

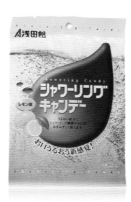

5. REFRESHING SWEETS

The flavour of this 'showering candy' is secondary. It's all about communicating the claim: refreshing. Making choices makes the packaging more powerful and distinctive.

6. EASY TO OPEN

Who hasn't experienced the frustration of trying to rip open a pack, only for it to completely tear apart? The solution is simple.

7. HEALTHY JELLY
Lots of sweets and foods with functional additives,
often especially good for a beautiful healthy skin.
This is an unappetising medicine-like jelly substance,
available in many varieties.

8. CHIPS CHARACTER
Cartoon characters are everywhere. This design from creator Kitakaze Masaru with has great shelf impact and direct appeal.

9. COFFEE
Optimal use of material. A foil pack with a window at the bottom. Subtle use of matt finish. A pity about the flavour description sticker.

麻布十番

ミナト商会　特製

ミートソース

10. CONDOMANIA
In the Condomania shop you are overwhelmed by condoms of all sorts, colours and sizes. A single picture speaks more than a thousand words.

11. PASTA
Less is more. No Italian atmosphere with this pasta, but instead a typical Japanese image.

Switzerland.

RELIABLE AND CLEAR COMMUNICATION

High points in creativity are not easily found in Switzerland, but everything is greatly reliable. Their traditional watches are extremely accurate. The country's borders are clearly demarcated thanks to the difference in the level of maintenance of the road surfaces and the customs offices on both sides. The streets are spotless and people are dressed smartly. All of this in air that is clean and surrounded by sparkling mountain streams and clear lakes. It cannot fail to pervade the minds of the inhabitants. They have a real sense of detail. Just look at the clear use of shapes and solid materials by architect Mario Botta (see www.botta.ch). He is from Ticino, Tessin in German, home to many wonderful villas that were designed by him. Fortunately the Italian influence in this canton is not restricted to the language, but has spread to the local cuisine as well. In the super-markets you will find a mini-version of Switzerland. The garage is light, the barriers always work, the trolleys are clean, the aisles are neat and tidy, the signposting is clear, the shelves are properly arranged and orderly, the employees are attentive, and Italian, French and German articles are in plentiful supply. And of course there are many brands and packagings from neighbouring countries. But we can easily identify the typical Swiss designs: clear and reliable.

SWISS MILK CHOCOLATE WITH HONEY AND ALMOND NOUGAT

TO·MY·LOVE

·OF SWITZERLAND·

400 g

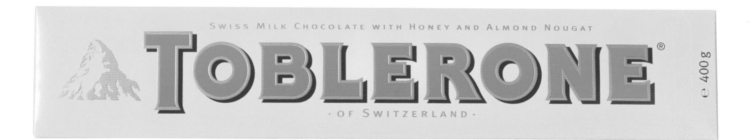

SWISS MILK CHOCOLATE WITH HONEY AND ALMOND NOUGAT

TOBLERONE®

·OF SWITZERLAND·

400 g

1. FAMOUS TRIANGLE

In 1867, Jean Tobler opened his confiserie special, quickly followed by a chocolate factory. In 1908 his son introduced the Toblerone in its familiar triangular shape – a design that has succeeded in keeping its competitors at bay right down to the present day. An extra sleeve gives a special touch.

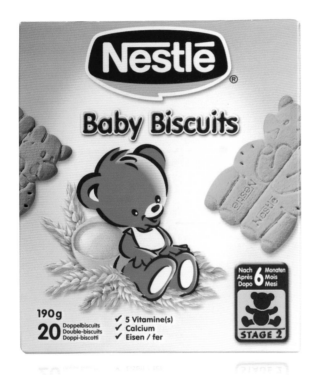

2. FROM THE CRADLE TO THE GRAVE
Nestlé can be found almost everywhere on the shelves. The logos used depend on the range and the target group. From baby biscuits to healthy snacks to keep you going.

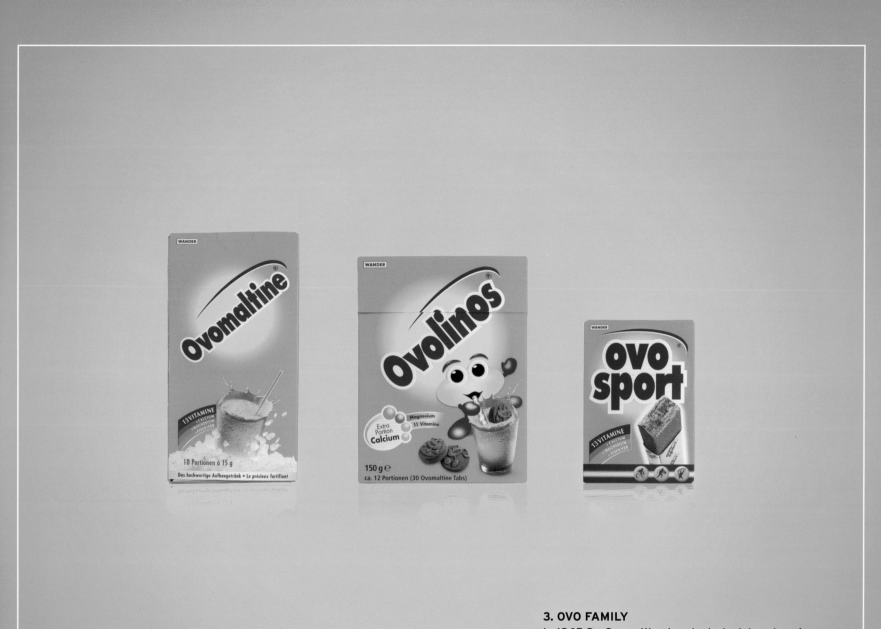

3. OVO FAMILY
In 1865 Dr. Georg Wander started a laboratory in which his son created Ovomaltine in 1904. Over the course of the following hundred years the brand has moved with the times.
New products with their own Ovo name make up a single recognisable orange family.

4. NOT MILKA
Milka is less prominent on Swiss supermarket shelves than you might expect. This leaves more room for the older Cailler, in existence since 1819 and now owned by Nestlé. An attractive combination of a traditional logo with a modern background.

5. ONE-TWO

An example of dual branding between the COOP house brand and Weight Watchers.
The striking light blue packaging can be found throughout the store with their low-fat, low-sugar and low-calorie promises.

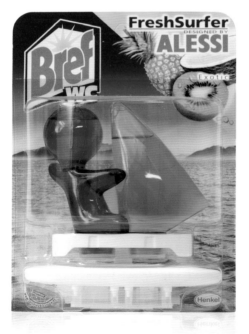

6. STRONG TOGETHER

Not just dual branding, Bref and Alessi, but also the trend towards dual products: a dual effect for the dishwasher and toilet.

21

7. DOUBT?!

In the fifties a Swiss family by the name of Zweifel ('Zweifel' means 'doubt' in German) started making crisps. The aesthetic design for these Oriental salt products is admirable, but the combination with the dated logo is rather dubious.

8. SWISS HERO
Hero has existed since 1886 and is also a Swiss brand by origin. Even tinned sausages are available under the brand. The new owner, Dr. Oetker, is streamlining the range. Fruit is to remain one of the central pillars and this means Hero has jammed a large part of the market with different flavours.

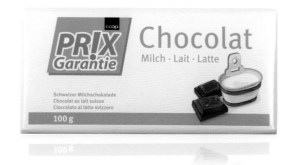

9. VALUE FOR MONEY
COOP has its own sub-label for those with smaller pockets: Prix Garantie.
A clear message with no taste.

10. PREMIUM HOUSE BRAND
COOP has 1500 stores in Switzerland. The COOP Fine Food packaging is highly reminiscent of silver premium lines in other countries.

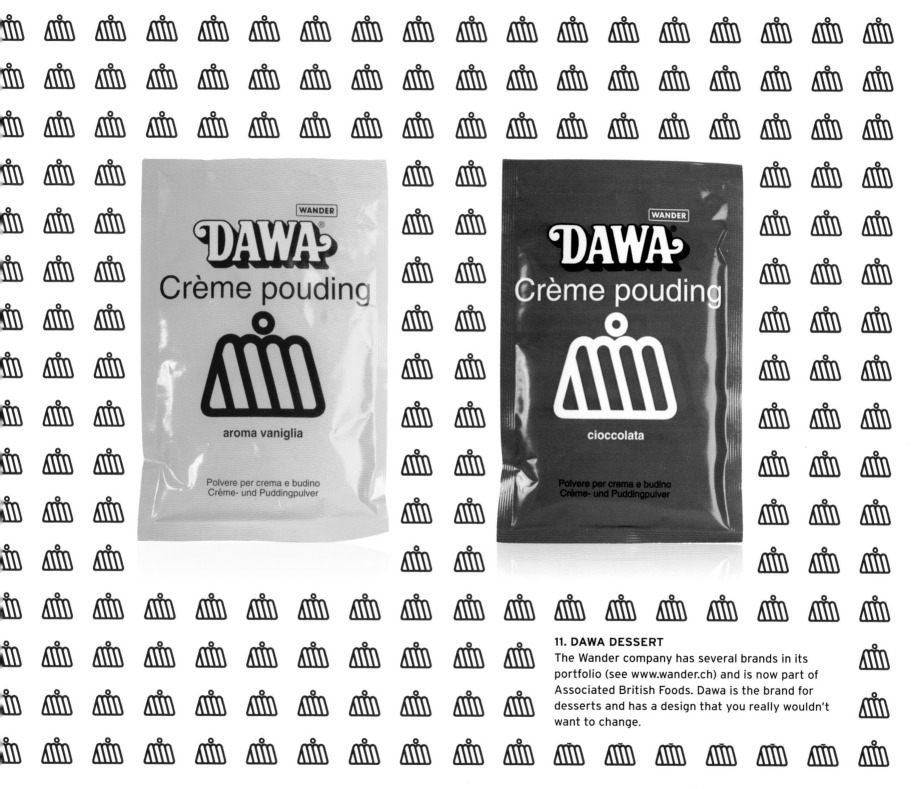

11. DAWA DESSERT
The Wander company has several brands in its portfolio (see www.wander.ch) and is now part of Associated British Foods. Dawa is the brand for desserts and has a design that you really wouldn't want to change.

FINLAND

Finland is seen as a modern design country, particularly as far as industrial design is concerned. For years brands such as Marimekko, Araba and Iittala have helped build this image. The Fins themselves look to Sweden for inspiration and especially anything from Stockholm. Swedish is everywhere, everything in Finland is bilingual. Sweden has, maybe even subconsciously, made an even larger contribution to the modern image of Scandinavian graphic design. Finland itself is a more traditional country with an agricultural character. This leads to conservative ideas and simplicity, and this is reflected in the graphic design of the packaging of everyday products. For a long time little attention has been paid to packaging design, as can be seen in the paucity of design companies. A shopping trip in the somewhat provincial city of Helsinki reveals a great deal of the traditional packaging which the Fins seem so attached to. Modernization is not always a success and manufacturers are often called to order by the consumer.

However, this does not prevent them from trying out new ideas, so that now and again a new jewel can be found on the shelves.

1. FINNISH GIRL
Everyone in Finland is familiar with the girl in this picture. She is the old-fashioned prototype of a Finnish girl: blonde, strong, healthy and hard-working. On the original packaging she was also shown holding a sickle, but this was dropped because of its association with Russia.

2. MARKET LEADER OWNED BY UNILEVER

Turun sinappia means literally 'Mustard from Turku'. When there was a threat that production would be transferred to Sweden this nearly lead to rioting in the streets. This is a piece of Finland's cultural heritage, now owned by Unilever.

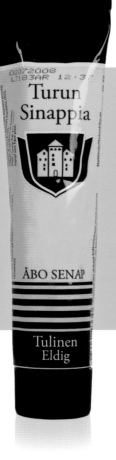

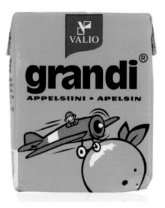

3. CHILDREN'S HERO

All Finnish children have grown up with Grandi.
The character Kari Grandi was brought to life by
advertising: he became a true superhero.
His name has been borrowed from another
hero: Cary Grant.

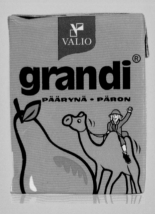

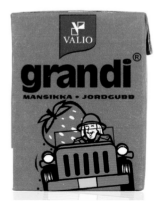

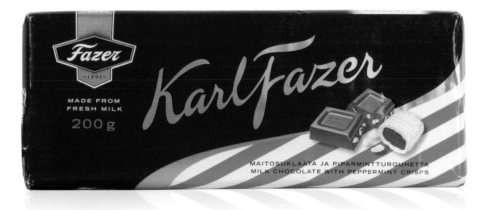

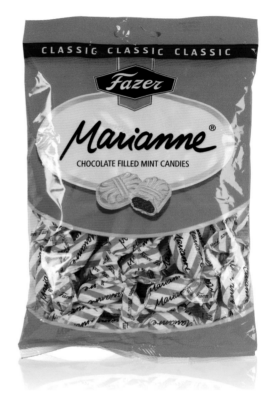

4. CROSS-POLLINATION
Karl Fazer is a huge Finnish chocolate brand which was established in 1891. The colour blue, which since time immemorial has stood symbol for the Finnish lakes and independence, has since 2001 been the first registered colour mark. The mint sweets are filled with chocolate, and the chocolate sweets with mint.

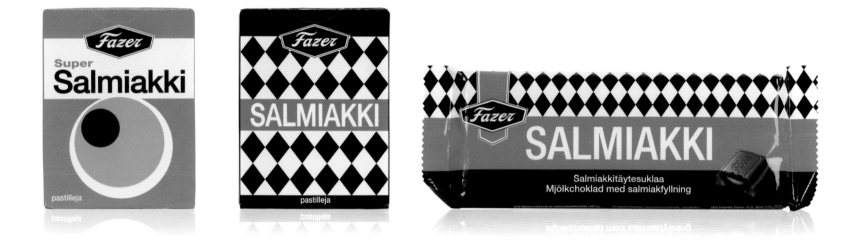

5. A QUESTION OF TASTE
Typical Finnish design for typical Finnish
confectionery. It could just as easily be the print on
a dress by Marimekko (which literally means 'Marie's
dress). The sal ammoniac powder is also used to
flavour chocolate bars.

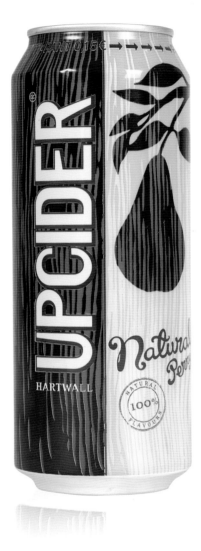
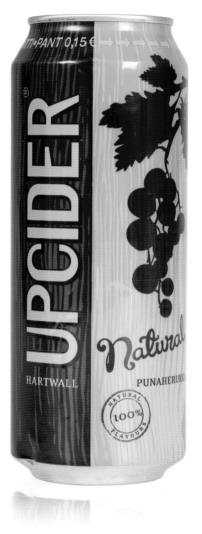
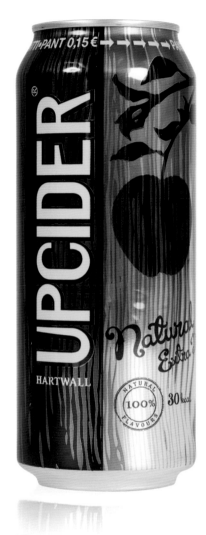

6. UPCIDER
The men may drink beer, but the women have their cider, and in ½ litre cans. Upcider carries a modern design with graphic elements borrowed from nature and the great outdoors.

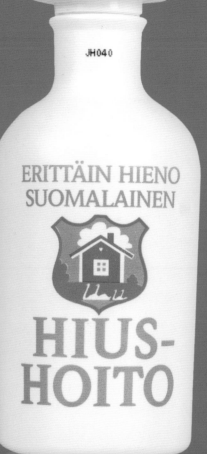

7. VERY GOOD FINNISH
The name Erittäin Hieno Suomalainen means something like 'Very Good Finnish'. This shampoo can be found in every sauna. The design is more than 20 years old and was created by advertising bureau Womena owned by Kirsti Paakkanen. This grande dame was also, at the age of eighty, owner of Marimekko.

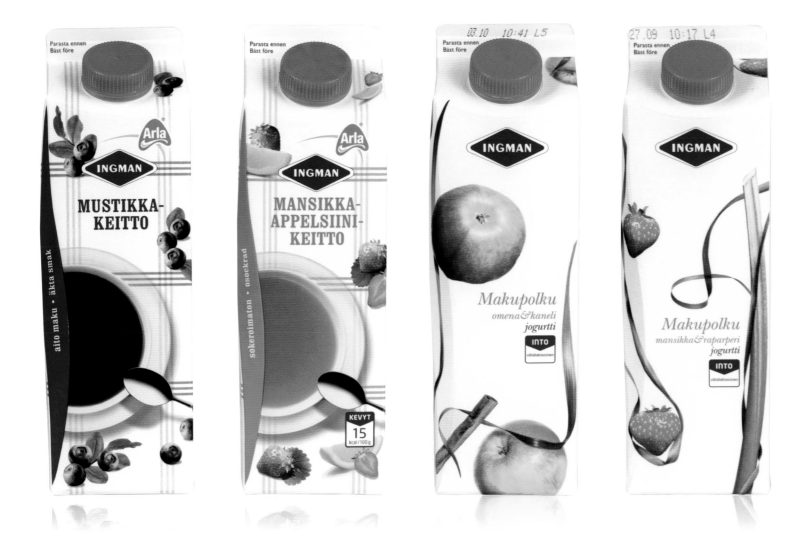

8. SWEDISH AND FINNISH
The Swedish brand Arla was unsuccessful in its attempt to take the Finnish market by storm, so they bought up the Finnish brand Ingman instead. Packaging of dairy products carries both names. The fruit drinks are still exclusively Ingman.

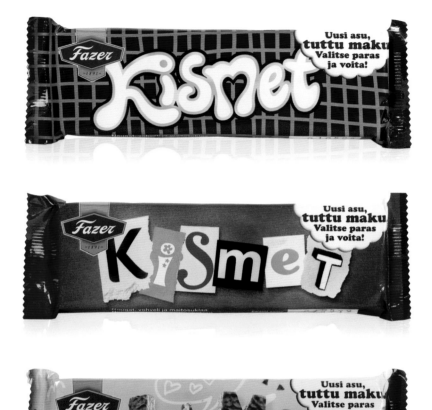

9. COMPETITION
Given the conservative nature of the Fins, changes are brought very carefully. When Kismet was long overdue for a make-over, the various options were presented to the consumer who could cast his vote in a competition. The first option is the closest to the old design.

10. BLACK LIQUORICE
Fazer also makes liquorice. These black faces are nowadays not really political correct

RUSSIA

CLARITY
VERSUS INTENSITY

Russia is a global empire which is changing at break-neck speed. Moscow is now the most expensive city in the world. Every item of Western luxury is now available in the GUM department store, while traditional matryoshka dolls are on sale from the stalls at the front. Old women beg and young men flaunt their jewellery. It is these contrasts that make the streets so interesting and lively. And it is contrasts that form the basis for contemporary Russian design. Good observation provides an interesting insight into the complicated soul of the average Russian, which is reflected in the design that you come across in the regular supermarkets.

Russians are surrounded by a rich and seemingly end-less countryside with dense and dark forests, clear and open lakes, deep and dangerous rivers, and vast and lush pastures. These differences can be seen in the field of design: clear and intense colours, open and cluttered spaces. In addition, the Russians are closely attached to their heritage, but at the same time absorb and adapt every foreign influence. You see packages that refer to tsarist and communist traditions and yet there are also modern examples with European culture, Asian simplicity and American youth. All of which makes shopping in Moscow a real cultural feast.

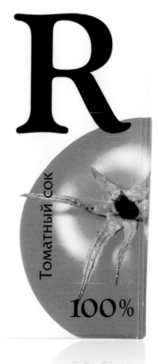

1. I AM
The contrast of Russian nature. 'Я' means 'I' in Russian and the bright colours help it stand out. The modern Rich, with each side bearing one letter of the brand, depicts the clear variety. Two striking personalities on the fruit juice shelves.

37

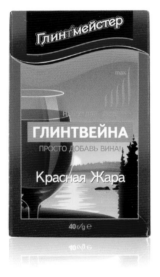

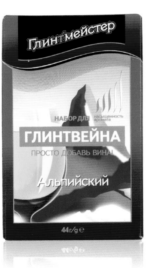

2. WARM DRINK
Glintvein Master make bags with herbs and all kinds of ingredients to be added to warm wine. The aroma is strengthened by the colour.

3. FRENCH BAKER
In 1853, Louis Bonduelle and Louis Lesaffre started producing yeast. Now, the Lesaffre Group is a bio-technical company. The Russian branch is called Saf Nava, after the river of the same name. The Saf family has now also acquired an Italian pizza bakery.

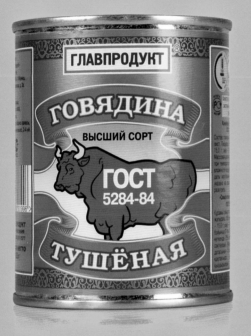
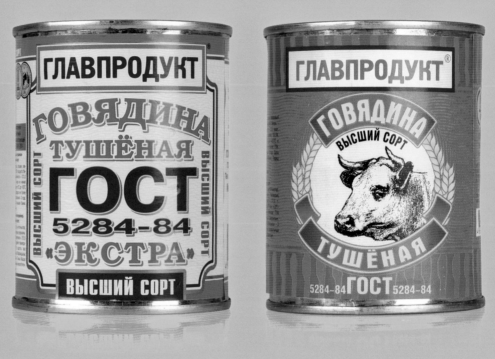

4. ISO STANDARDS
The same beef product in three different packaging versions, all from the same brand, is very reminiscent of the Soviet era. The words 'Union State Standard 5284-84' are right in the centre of the design.

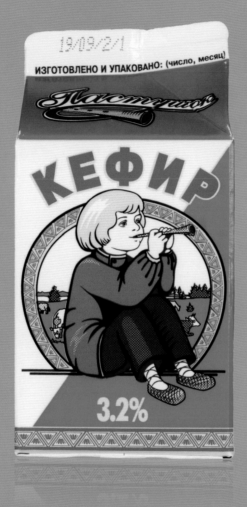

5. PASTORAL
The brand name Pastyshok literally means little Shepherd. The rather fetching boy, wearing his traditional Russian shoes, plays the flute. The location of the brand on the packaging changes according to the variety.

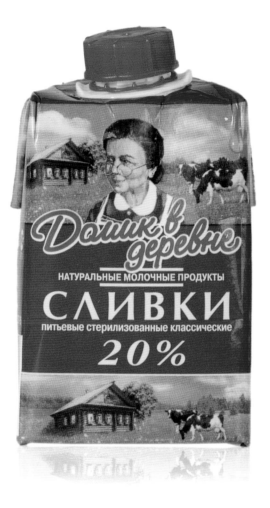
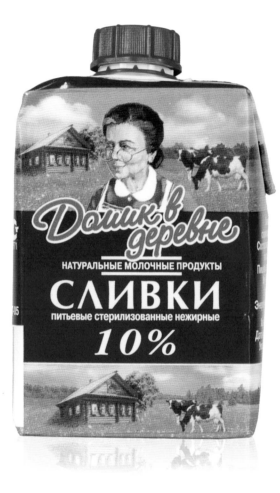

6. OUR VILLAGE

Yet more nostalgia. The words 'Domik v derevne', which mean 'house in the village', are positioned underneath the ubiquitous grandmother figure. This dairy product also depicts the rustic life that every Russian dreams of.

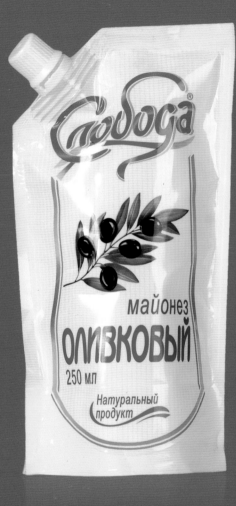

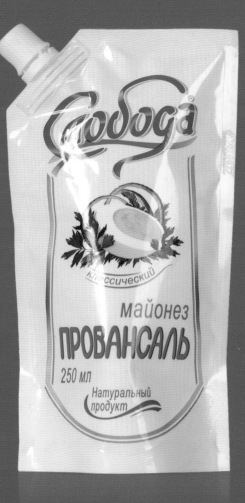

7. SQUEEZY MAYONNAISE
There are hardly any jars or upside down bottles of mayonnaise to be found in the supermarkets. The standard offering is a stand-up packet, from which you squeeze out the contents. Sloboda is the local hero on the shelves.

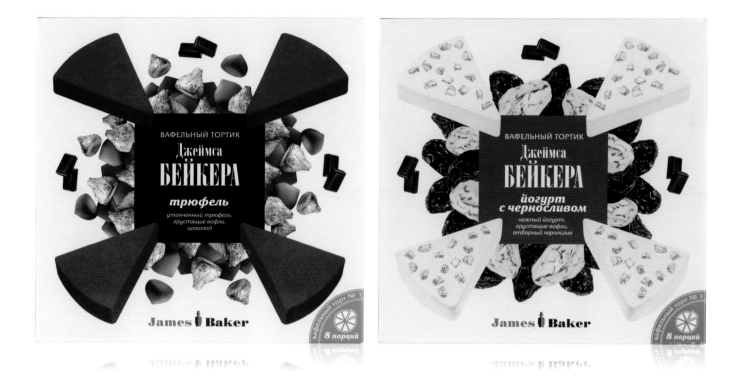

8. ENGLISH TOUCH

'James Baker' looks very different when written in the Cyrillic alphabet. In fact, the text in the middle has no logo effect whatsoever. The English touch underneath stands out more. As indeed does the modern design of these waffle cakes.

43

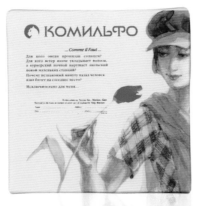

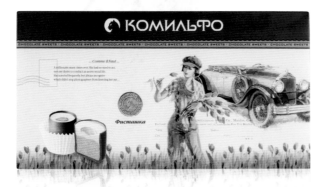

9. COMME IL FAUT
French was the lingua franca at the tsarist courts. The Russian brand Comilfo, which has only been on the market since 2004, is based on the French 'comme il faut.' These top-notch chocolates are presented in luxurious and romantic boxes

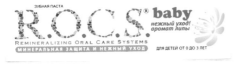

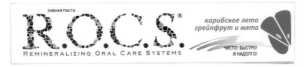

10. BRILLIANT SMILE
ROCS stands for Remineralizing Oral Care Systems and comes from Tallinn, Estonia, which used to be part of the USSR. The packaging clearly shines out on the toothpaste product shelves.

11. GLAMOUR!

Russian women like to be ultra-feminine. High heels and short skirts can be seen everywhere on the street nowadays, and they all smoke super-thin cigarettes. Elegance is not something you can buy. Glamour, it seems, is.

Hungary

FROM THE EAST TO THE WEST

Buda and Pest lie on either side of the wide River Danube. The layout of the city can be compared to Prague, with the new city situated on a flat riverside location and the old fortified city on the hills on the other side of the river. However, Budapest is not quite as beautiful as Prague so it attracts fewer tourists. Influences from the East are clearly evident, such as the Turkish baths where for centuries water from the hot springs has been bubbling under the dome of the Ottoman Rudas Baths which dates back to AD 1550 and where men and women are kept strictly apart.

Budapest is clearly the capital of a proud Hungarian Empire in decline. Since the time of the Habsburgers and King Bela IV, who made Boeda the capital in 1247,

the city has been unable to regain its former glory. The city centre seems somewhat lifeless: all commercial activity has been banned to the outskirts of the city. The chic department store Luxus is holding a closing-down sale; the characteristic Gerbaud patisserie is under threat from the advancing C&A culture; an ordinary supermarket is nowhere to be found. The euro has yet to take the place of the Hungarian forint.

But the focus is definitely on the West. This can be seen in the design of the packaging on everyday products, which shows an eclectic mix of Western innovation, family traditions, archaic concepts, influences from the surrounding countries and genuine pearls of authenticity.

1. ENERGY DRINKS

Bear is on the menu in Hungary. Blue Bear Energy Drink is the latest feeble imitation ('Selected for SPAR') of market leader Red Bull. Bomba stands out as an independent brand with its origins in Austria. But of course that was also once a part of the Austro-Hungarian Dual Monarchy.

47

TORTABEVONÓ
TEJ

Nettó tömeg: ℮ 100 g

2. CHOCOLATE

The chocolate market in Hungary is dominated by Milka. For those looking for something non-Swiss, but with a real heart for the West, there is of course Americana chocolate. However, now that the iron curtain is well and truly history, does this name and packaging still really motivate the consumer? Match Supermarket has PROFI as its house brand. The red and white packaging with the household purse jumps out at you throughout the store. This type of own brand based solely on the concept 'cheap' is now outmoded in most western societies. Why punish the consumer for choosing a cheaper alternative? Are PROFI products lower quality?

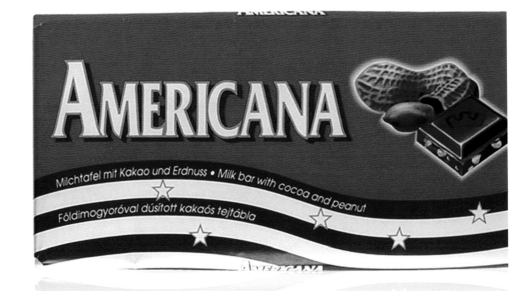

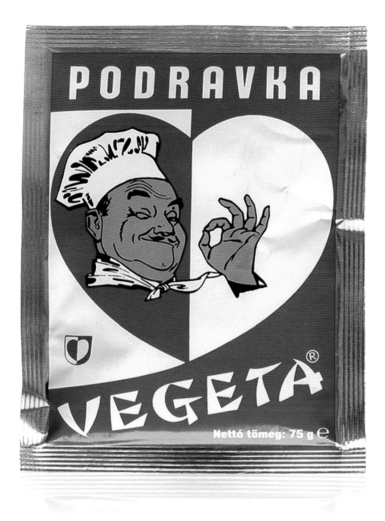

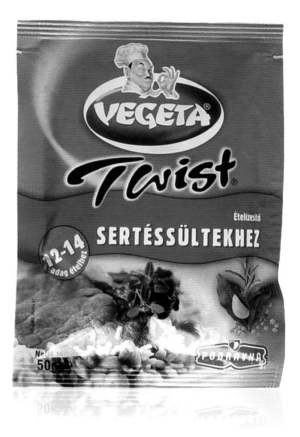

3. VEGETA BY PODRAVKA

Podravka was nationalised in 1947 and privatised again in 1993. This Croatian company is focusing on Central and Eastern Europe. The brand Vegeta, for a flavour enhancer, is obtainable in 40 countries, and has been on the Hungarian market since 1967. The basic variety does not seem to have changed at all since then. The new Twist line has been clearly modernised: the Vegeta logo is less sharp and the chef is maybe a little too polished now.

4. UNIVER

Fifty percent of all mayonnaise sold in Hungary is from Univer, originally a cooperative enterprise with its own shops. However, now the Univer food products are stacked up alongside products from competitor Unilever. It seems that there is room for both of these names.

5. HUNGARIAN HERBS AND SPICES

How Hungarian can you get? Janos Kotanyi was born in Hungary in 1858. Before long he was famous for his powdered paprika of unequalled quality. These days Kotanyi is still a family company with a huge range of herb and spice mixes. A modern assortment with a distinctive and simple design: incorporating a strong basic shape, an own colour and most of all making use of superior-quality photography.

51

6. COFFEE

Douwe Egberts is taking over Europe. How is the name pronounced in all those different countries? By adding 'Karavan' it becomes Hungarian Gypsy coffee. The aroma rises up to meet you from the cup. The German Tchibo brand (also owners of Beiersdorf) brings you the aroma straight from the coffee bean.

7. PACKAGING OR LEAFLET?

Eduard Haas invented baking powder more than a century ago, and the Haas company which competes with Dr. Oetker in a number of markets is still run by his heirs. The modern logo is slightly more legible (see www.haas.hu) but the packaging of the product 'culinary glucose' looks more like an outdated leaflet promoting a healthy lifestyle.

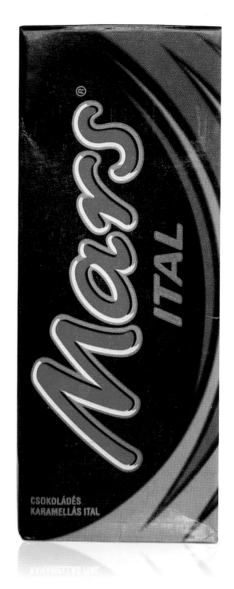

8. SPAR VERSUS DR. OETKER

Dr. Oetker has been a family business ever since Dr August Oetker developed a special baking powder in 1891. Since then Dr. Oetker has taken the world by storm with its baking products and other food products. The finished product always takes a prominent place in the packaging. This principle is often copied, especially by private labels. SPAR is verging on plagiarism here.

9. MARS

Could it be that people think that a Mars drink promoting 'energy' doesn't have to appear particularly appetising?

53

China

UNLIMITED POSSIBILITIES

A country with thousands of years of culture and long isolated from the outside world, now China has a flourishing economy and is open to the world. The country's self confidence is growing along with its success, and this means it is no longer happy to simply import and copy goods. Chinese traditions are being brought up to date and are finding their way abroad. Modern Chinese art is extremely popular, and design is sure to follow. The trendsetters in the New China were born in the Maoist period but they have thrown off the shackles of the strict communist philosophies under which they were raised. They are open to influences from the West and also Japan and this, combined with their own cultural baggage, is creating a new modern Chinese identity.

Shanghai, host city for the World Exhibition in 2010, is where all these developments are coming together. Modern architecture is taking over the old city and the public spaces are being filled with art. The rural population is rapidly becoming urbanised and (foreign) companies are springing up everywhere.
The port of Shanghai is the most international place in all of China. Inspiration is everywhere, including the local supermarket. The packaging of everyday products shows the unlimited opportunities in China: traditional versus modern, tranquil versus extrovert, symbolism versus vulgarity, realism versus abstraction, dreams versus reality, kitsch versus art, and all that merging into each other. And this is just the beginning.

1. TRADITIONAL PACKAGING

Under the strict communist regime the use of expensive packaging materials and printing inks was just not done. Packaging was denounced as nonsense by the government, recycled paper was widely used. Now this communicates convincing basic products.

2. PRODUCT AS DESIGN

The product is vacuum-packed in (partially) transparent packaging, providing a surprising effect. The product becomes a part of the design.

3. OLD CHINESE IN A NEW COAT
Traditional porcelain and earthenware designs on
PET bottles. The Chinese decorations create a
charming image on a shelf not normally known for
its subtlety.

4. BLING BLING

A cigarette packet as an accessory. In a country where smoking is seen as common property and a form of social interaction, the number and variety of national cigarette brands is endless. The packaging of all these brands forms an exotic kaleidoscope of Chinese art and culture.

57

5. GLEAMING SMILE

No-one is worrying about an extra print run, special inks or expensive materials on the tooth-paste shelves. The packaging leaps out at you with its multitude of glitters and holograms.

6. MEDICINAL SHAMPOO
Shampoo to combat hair loss or dandruff is recommended by a serious doctor or film hero Jackie Chan. The text on the packaging emphasises the coming together of traditional Chinese medicine and modern technology.

7. FRUIT YOGHURT?
Mini 'yoghurt pots' turn out to contain a nourishing face pack.

8. FRUITY FACE PACK
The choice is endless: modern design with Japanese influences for an even more fruitful facial treatment.

9. WHITER THAN WHITE
Where in Europe there are products to give the skin more colour, the Chinese desire products which will make their skin whiter.

10. COSMETIC FRUIT
You might be expecting a cosmetic product, but this packaging contains dried fruit. The text on the packaging reads Fashionable Classic Food.

11. PERFETTI VAN MELLE WORLDWIDE
Perfetti Van Melle has a branch in Shanghai. The international Mentos brand is given local colour.

12. SWEETS WITH TRADITION

The traditional Fruittella design features monsters with no background. This is unacceptable in China so an exception has been made and a landscape added. Tradition in a modern form.

13. FANCY FOOTWORK

Enormous print runs and low costs mean that freedom of design is no problem. A brand can simply determine its own 3D shape, giving added value and creating more distinction.

Egypt

ARABIC DIVERSITY

The first united kingdom on the banks of the Nile in north-east Africa was established in 3200 BC. It formed the foundations of Egypt and one of the oldest and greatest civilisations of the world. The country has been exposed to every conceivable influence and rule: the Greeks, Romans, Turks, British and Persians are among those who have left their mark here.

In the seventh century AD the Arabs introduced their language and the religion of Islam. Now the country is 90% Islamic and Arabic is the official language. However, packaging is very often bilingual, with Arabic on one side and English on the other.

A walk round any local supermarket is enough to show that the idea that packaging in Islamic countries is not allowed to carry any pictures of people belongs in the realm of fables. The diversity of cultural influences in the Arab Republic of Egypt is striking: Western, Oriental and local signals follow on after each other or merge together. Outside the tourist shops there is not a single 'typical Egyptian' hieroglyph to be seen on packaging. Everywhere you go, small single-portion, or even mini-single-portion packages are sold, bringing products within reach of everyone.

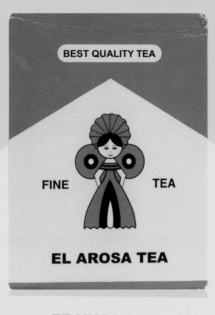

1. MARKET LEADER IN TEA
One of the many examples of bilingual packaging:
the El Arosa tea brand, launched in 1980, has now
captured 70% of the market. Arosa means bride.
According to the website, the familiar and very
popular red and yellow bride has undergone a recent a
restyling and is now slimmer, taller, happier and even
trendier!

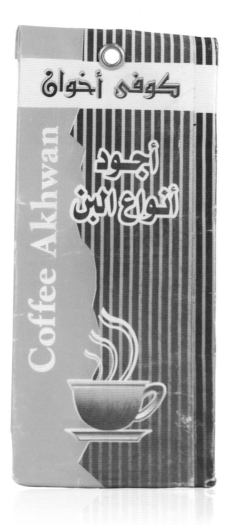

2. AND THEN THERE IS COFFEE
Coffee Akhwan does not use a brand own typography,
but is instantly recognizable by the vertical stripes
on its characteristic 50 gram packs.

3. STOCK CUBES
Even stock cubes can be bought singly. The packets come in a strip and can be found hanging by the checkout; not for travel use, but handy for the smallest budget. You can recognise the Calvé logo around the Arabic name.

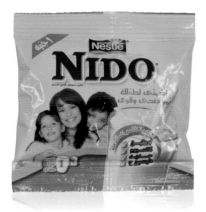

4. INSTANT AND WITH MILK?
The international Nido brand is focused on powdered milk products. The Western-oriented 'happy family' laughs at you from the packaging. Nestlé also has three-in-one sachets: with coffee, sugar and 'coffee mate', although this is not real milk.

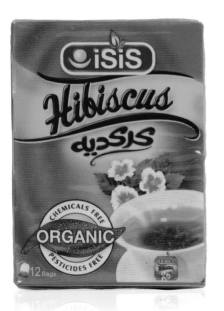

5. FERTILE DRINK
The Sekem Group is involved in biodynamic agriculture and has its own shops. One of its brands is Isis, which markets bread, dairy products, fruit juices, herbs and spices, coffee and tea. Isis is one of the most important goddesses of Egyptian mythology; she is the goddess of fertility.

Nutrition Facts
Each 10gm Contains

6. CHIPSY
In 1998 Pepsico took over the Egyptian Chipsy brand.
The brand is so successful that it has not (yet) been
superseded by Lays, although the logo is similar.
The back of the packet is interesting: it shows the
entire process from the potatoes in the field through
to cutting and deep frying, and with a different
'serving suggestion' on every packet. An ideal part of
the meal!

7. THE LAUGHING COW?
ArabDairy, a young company which focuses on producing and selling cheese, uses a happy cow illustration on its packaging. The Laughing Cow ('La Vache qui rit') cheese company will probably be less amused.

8. SUPERSWEET
Wrigley's chewing gum is sold per piece. The extra-bold candy colours overpower the symbol for extra calcium that is supposed to protect the teeth from this sugary attack.

9. FOR THE WATER PIPE
The El Hannaway Tobacco Company, founded by
its namesake in 1933, has a wide range of hookah
tobacco. The flavours are tooth-achingly sweet; the
tobacco smells like Turkish Delight and looks much
the same.

10. MINI PACKAGING

Cadbury's Clorets are available in a mini-mini packet (measuring less than 2 x 4 cm). The Clomex brand also states 'the breath freshener' on its packaging, but is nowhere to be found on the Cadbury website. Could this be a Battle of the Titans in the market?

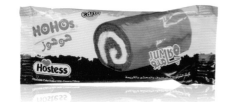

11. UNTIDY BRANDING POLICY

Edita operates in the baked goods sector, with a variety of Swiss rolls. The Edita, Hostess and Hohos logos are spread randomly across the packaging, and there doesn't appear to be any consistency throughout the entire product range.

Spain

STAYING TRUE TO ITS ROOTS

At the ticket office of the Guggenheim Museum in Bilbao are piles of information books in a wide range of languages: Spanish, Catalan, Basque and English. You could be forgiven for thinking that Spain is a divided country. But where multilingual packaging is mandatory in countries such as Belgium and Switzerland, the Spanish supermarkets tell a different story.

In the supermarket the shelves reveal clearly the Spanish eating habits. The design of the local brands, which are stacked casually next to the well-known international brand names, and in some cases have pushed them aside completely, gives an insight into the stomach and head of the proud soul of the Spaniard, with much authenticity and many local heroes.

And they certainly know how to eat well. In Basque country they serve so-called pinxtos instead of tapas. At four in the afternoon all the bars in San Sebastian, Donostia fot the Basques, are laden with huge dishes which are richly decorated and packed with the tastiest snacks. Guaranteed to raise the holiday and party spirit. If you want to eat after this, for example in the world-famous three-star restaurant Arzak, you will have to wait until after 9 p.m. Of course you can do your own shopping and take inspiration from the richly filled shelves.

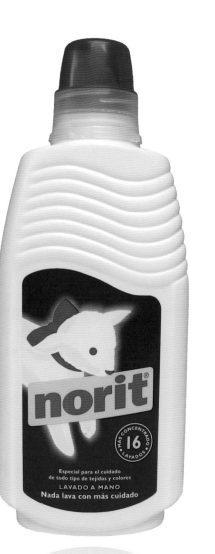

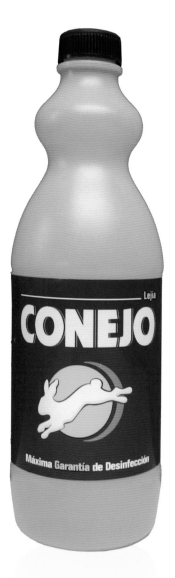

1. HAPPY ANIMALS
A cheerful and strong design. Conejo means rabbit, this brand of bleach is from Henkel. Norit is a brand of detergent for hand-washing laundry; as gentle as a lamb.

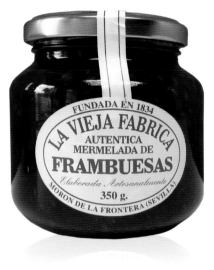

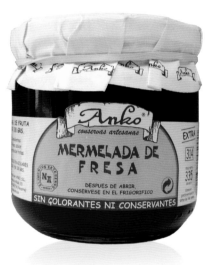

2. AUTHENTIC JAM

'La Vieja Fabrica Autentica Mermelada de Frambuesas' speaks for itself and the simple label and paper seal confirm its authenticity. As far as its name goes, Anko seems more industrialized, but a visit to the website at www.anko.es will soon show you otherwise.

3. TINNED FOODS

Tomatoes and sweet peppers are a staple of the Spanish kitchen. Orlando is a Heinz brand and both brands of ketchup can be found on the shelf. But if you want good tomate frito you really need Orlando. Bebrico keeps a sympathetic distan ce with its modest paper label and graphic design.

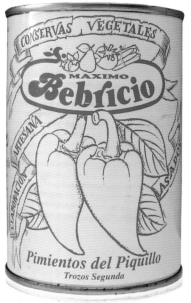

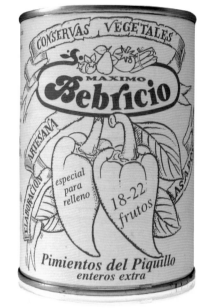

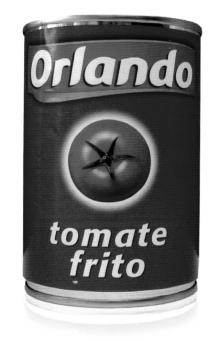

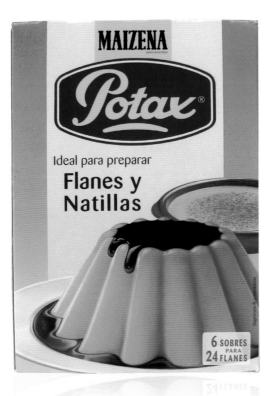

4. MAIZENA

In 1862 the Duryea brothers introduced Maizena to the market in the United States. Both names are now part of the Unilever concern. In the Netherlands Unilever's position has more or less led to Maizena being a synonym for cornflour. The section on Duryea on the Unilever website refers to Duryea as 'all-purpose thickener and maizena'. However, in Spain Maizena functions as a brand in itself and even as an endorsement on a variety of brands and wide range of products: a true binding agent.

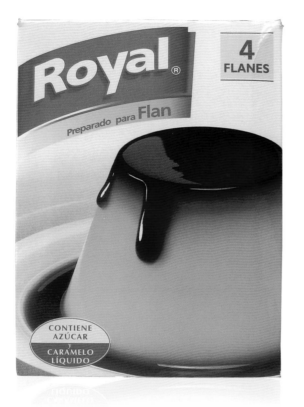

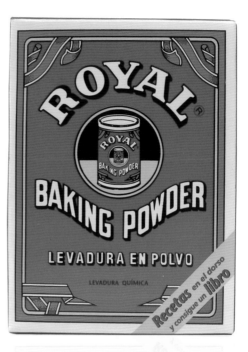

5. ROYAL
Royal Baking Powder was developed in 1863 by an American. These days the Royal brand is owned by United Biscuits. The classic design dates back to around 1890. A modern version of the logo is used for the range of dessert products, but is the name itself enough to make the connection?

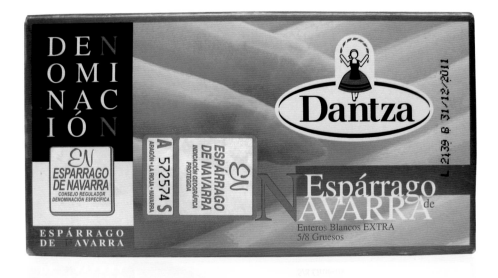

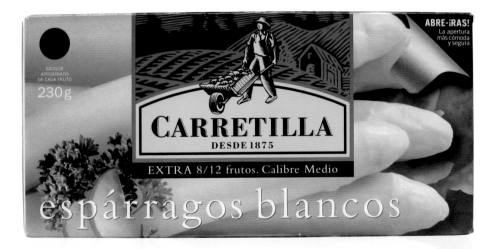

6. AN ABUNDANCE OF ASPARAGUS
An unexpectedly wide display of various brands of white asparagus, and not a single sign of a known international brand. Carretilla, founded in 1875, imports asparagus from far-off China whereas the more Spanish-looking Dantza brand gets them from Navarra. Both packages show firm, fat stalks, but in reality the asparagus are thin and limp.

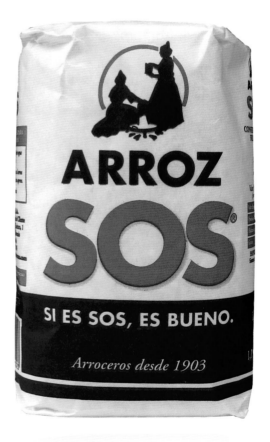

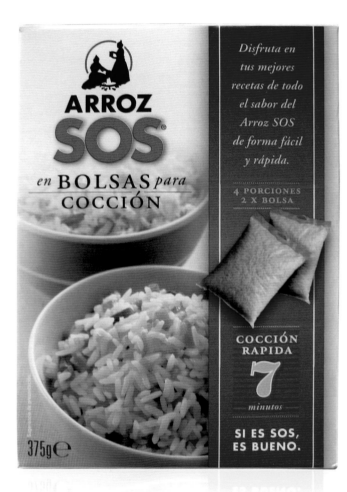

7. HELP, RICE!
SOS rice is available in huge sacks and small
packets. It is interesting to see how a dated logo
can function well on modern packaging.

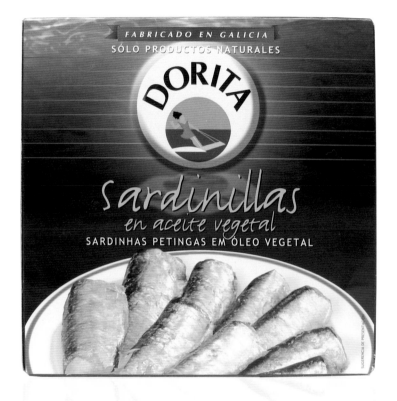

8. TINNED FISH

A great deal of fish is eaten between the coasts of the Atlantic Ocean and the Mediterranean Sea. All shapes and sizes of fish are tinned and marketed in good-looking cardboard packaging. Dorita, a brand from the coast of Galicia, promises the tastiest the sea can offer.

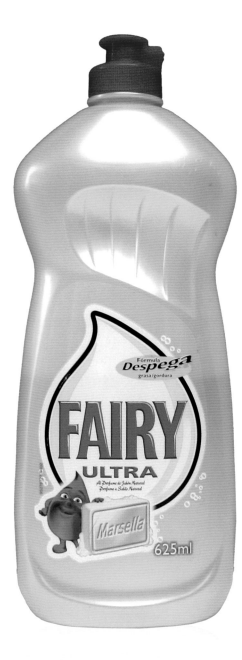

9. AND THEN THERE'S THE WASHING UP
The strength of an international brand, for Fairy liquid is instantly recognizable under the name Dreft with the same design in the Netherlands. The Spanish version has an unusual form of ingredient branding: a bar of Marsella hand soap? This is nowhere to be found on the supermarket shelves.

turkey

ON THE CUTTING EDGE OF ASIA AND EUROPE

Take an inspiring trip to Istanbul, formerly Constantinople, the centre of the once-glorious Byzantine and Ottoman Empire. When the modern state of Turkey was established in 1923, Istanbul lost its position as capital city to Ankara. However this has not stood in the way of the city's development. Although Turkey is aiming for membership of the EU, a sign on the eastern bank of the Bosporus at the heart of the metropolis of Istanbul reads 'Welcome to Asia'. This reflects the cultural dichotomy of the city which makes it so fascinating.

The dichotomy of East and West, tradition and renewal, Islam and Christianity. The contrast between a visit to the Blue Mosque and Club 360° just couldn't be greater. In the Grand Bazaar, unfortunately a real tourist trap, a few examples of typical Turkish packaging can still be found, but hardly any remain in the local supermarket. There you will come across all the international brands, alongside a number of national names. The question remains: will these brands, despite their charm, be strong enough to take on the European market?

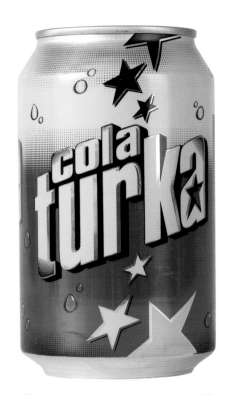

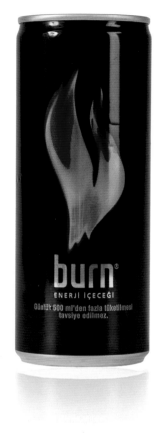

1. NATIONAL VERSUS INTERNATIONAL
A couple of years ago the successful brand Cola Turka was launched with great national pride and inspired by anti-American feelings. The red and white colours take their inspiration from the Turkish flag, coincidentally the same colours as Coca-Cola. Burn is Coca-Cola's answer to the success of the new energy drinks.

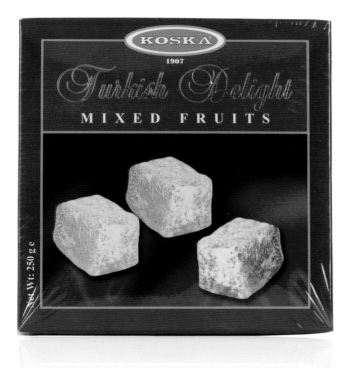

2. TURKISH DELIGHT

The Koska company has been producing Turkish Delight for over a hundred years and also exports this traditional delicacy in many shapes and forms.

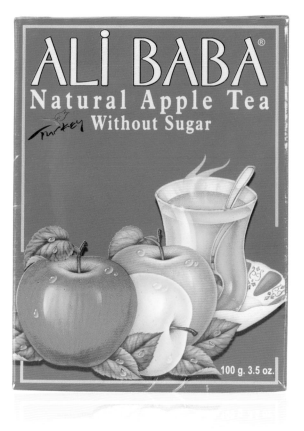

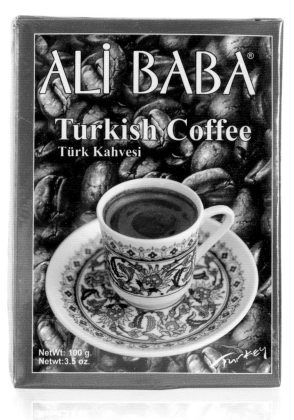

3. TURKISH TALE

Ali Baba is a character from a story from the Arabian
One Thousand and One Nights. Now the Ali Baba
brand is maintaining the Turkish tale with its Turkish
Delight and Turkish tea and coffee in traditional
packaging but carrying the modern Turkey logo.

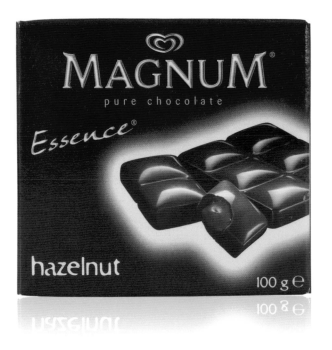

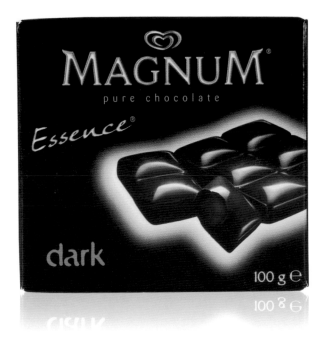

4. MAGNUM CHOCOLATE
This is an interesting brand extension by Unilever:
Magnum Chocolate. In Turkey the Unilever ice brand
is called Algida, but even though the packaging is
monolingual, the endorsement is only visual.

5. ÜLKER CHOCOLATE

The local supplier Ülker, which started out as a family business in Istanbul but is now a listed company and exporter, also manufactures Cola Turka. The packaging varies greatly and the endorsement is not presented clearly.

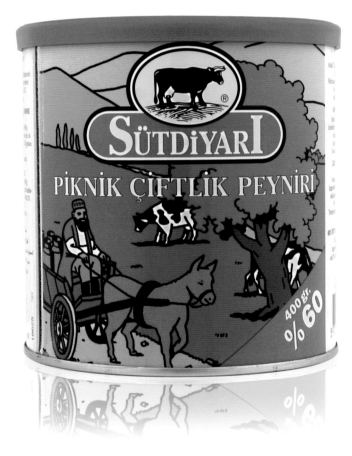

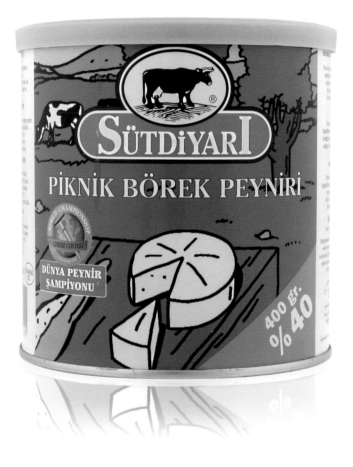

6. DAIRY LAND
Sütdiyari means Dairy land. The packaging is
promising in a friendly way an authentic Turkish
picnic cheese. However it is made in Denmark by
Nordex Food.

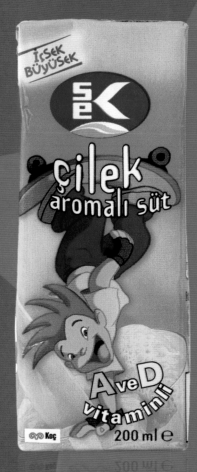

7. FOR THE KIDS
Sek is a manufacturer of dairy products and has a
great drink for kids that is packed with vitamins A
and D. Skateboards and skeelers are international.

8. INNOVATIVE

In 2003 the female CEO of Doga was voted Most Innovative Entrepreneur of the Year by the United Nations Economic Commission for Europe (UNECE). The company was established in 1989 and produces a wide range of healthy foods with no additives. An innovative packaging for sugar is the result.

9. LOCAL CLASS

Kenton is just one brand from the Turkish Tibet company. A completely ordinary dessert mix is presented with pure class.

Thailand

CHEERFUL AND PEACEFUL

Thailand means literally 'Free Country'. It is the only country in South-East Asia never to have been colonized by a Western power. The kings managed to maintain good relations with other world powers. King Bhumibol (Rama IX) was crowned in 1946, making him the longest-reigning monarch. He has much influence within his parliamentary constitutional monarchy and is adored by his people. The population of Thailand is mainly Buddhist and this has determined the country's culture. Buddhism, that has never been the cause of a war, differentiates between four elevated states of mind: harmony, joyous appreciation, compassion and kindness. The Thai society is drenched in these characteristics. Peaceful Thailand is the country of the smile. Its people are most engaging and polite, adapt quickly and readily absorb elements from other cultures. This is reflected in the supermarket packaging: cheerful, friendly and peaceful. Sometimes purely in Thai, but often also in English.

1. JOLLY LOLLIES?

The brand Pelotty from the Thai Glico company is barely discernable on the packaging of these jolly lollies. 'Fried egg' and 'Fish' are not the only flavours. 'Whale' and 'Chicken' are also available. Childishly sweet.

2. BANANA SWEETS
Thailand is joining in with the trend of making the product visible through the packaging, but this black 'Banana Candy' needs a little help to anticipate the right taste experience.

3. CHEERFUL CHARACTERS
The snack shelves are filled with cheerful characters, but this little mermaid is promoting pure seaweed.

4. THAI CRISPS
The international Lay's brand has chosen a Thai theme for its crisps and also adjusted the flavour to local requirements. In contrast, the local Unichamp company has chosen an American theme and flavour for its KobKob crisps.

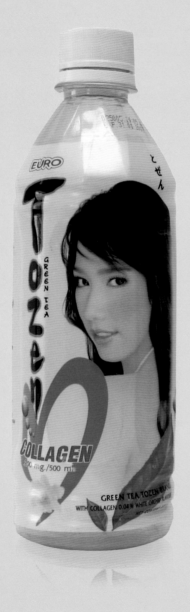

5. DRINKABLE COSMETICS
Green tea with collagen (0.4%) and orchid flavour-
ing promises a smooth, pale skin. The kiwi juice also
suggests that it is good for the complexion. Drink
yourself beautiful!

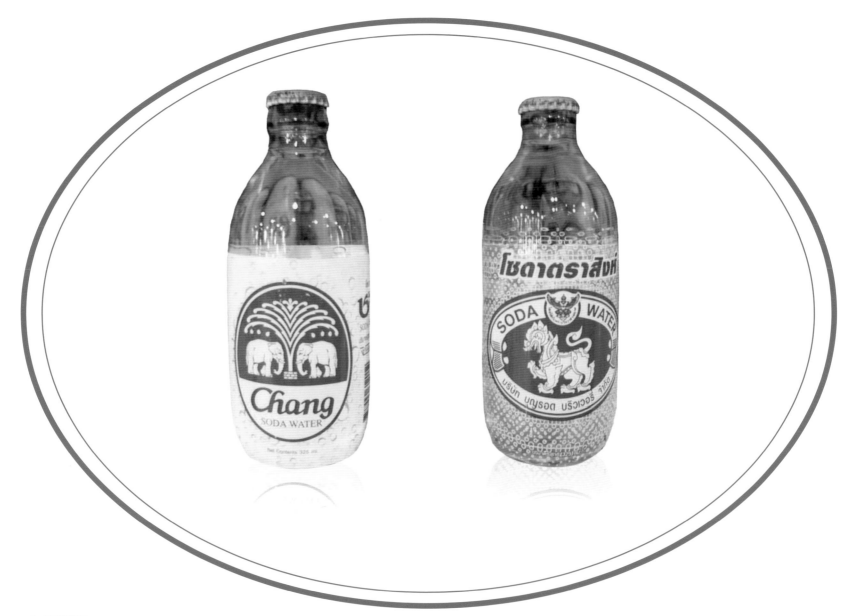

6. WATER
These bottles of soda water clearly show the influence of China in Thailand. Quite different to mineral water in the West with its pictures of mountains, streams and untouched nature.

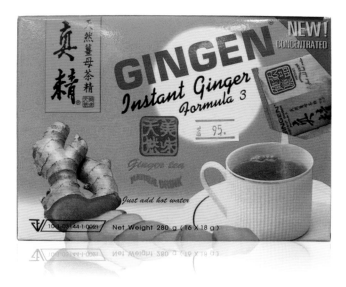

7. INSTANT GINGER
Presented as a fragrant cup of tea, in an English
and Thai version.

8. LITTLE BOTTLES IN A BOX
Power drinks with amazing claims.

9. SOUP PACKET
Dried herbs and spices in what looks like a soup packet. The front shows what's inside, and the reverse shows a splashing waterfall in the jungle.

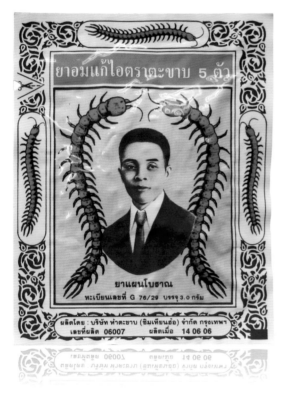

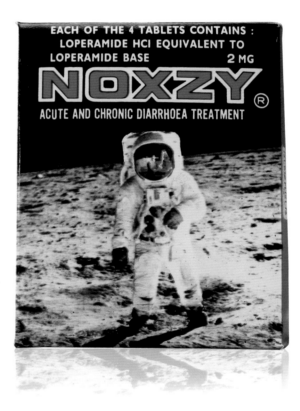

10. UNIVERSAL REMEDIES
Cough tablets made from centipedes? And tablets to cure acute and chronic diarrhoea: handy for a trip to the moon.

AUSTRALIA

RELAXED DESIGN FROM DOWN UNDER

Australia, the land down under, is the world's oldest and smallest continent with a current population of only 19 million. The name comes from the Latin 'Australis' meaning 'from the south'. The name Australia was first mentioned in English documents in 1625. Although an independent country, it is still ruled by Queen Elizabeth II. The Anglo-Saxon influences are visible everywhere. The shelves in the supermarkets are dominated by famous British and American brands. But industrious Japanese are also making their way to Australia, resulting in gems of local entrepreneurship. The country is a melting pot of cultures, each with its own traditions and tastes. The influx of people from all corners of the earth is resulting in a choice of products and cuisines, which is clearly reflected in the supermarkets.

Australia is a laid-back country. No overpopulation, no major natural disasters, no serious poverty. Instead, it has nice weather, a great outdoors and an easy-going population. Australia used to be called 'the lucky country' and many of its residents are convinced that their country is the best place to live. You'll find friendly service wherever you go. The Aussies are known as a pleasant, warm, informal and relaxed people. Its cuisine does not produce any culinary masterpieces. Instead, the supermarkets are stocked with everything you could possibly need for a barbeque. And the presentation is done in a laid-back manner. Your groceries are packed with a smile. Why do things the hard way? No rush, no stress, no hassle.

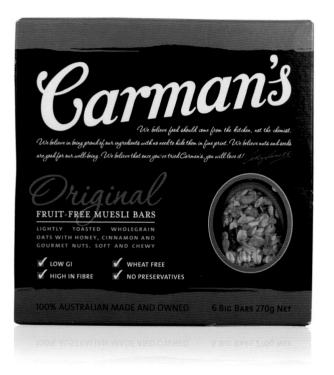

1. BLACK SUIT
The Australian Carolyn Creswell started making muesli while still a student and eventually turned it into a successful business. The front of each packet of Carman's reads: 'We believe food should come from the kitchen, not the chemist'. It's not only the striking black packaging, but also the text that makes the difference.

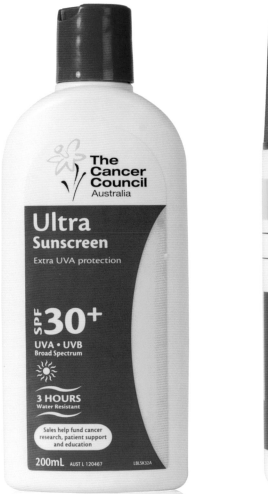

2. SUNTAN

The Australians are very aware of the dangers of sun tanning. The Skin Health firm has introduced a range of products under the brand name 'The Cancer Council Australia'. Part of the proceeds goes towards skin cancer research.

3. BBQ SPRAYS
Why do things the hard way? With so many barbeques, a way had to be found to simplify oiling the grid. The ideal solution came in an aerosol can, which has since become the norm. Red Island has oiled up the entire continent.

4. HEINZ DIVERSITY

A brand like Heinz can be found in various sections of the supermarket. The brand comes in many guises: basic, authentic or even forced contemporary. The question remains whether these differences could add up to a credible brand personality.

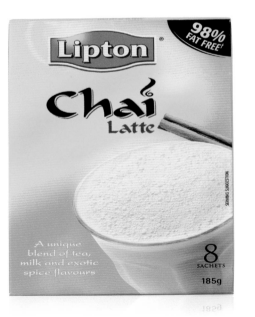

5. TEA IN ASSORTED STYLES

The British Lipton has spruced up its range with Oriental tea and Italian latte. While the local Daintree Tea prefers to keep to a more traditional approach.

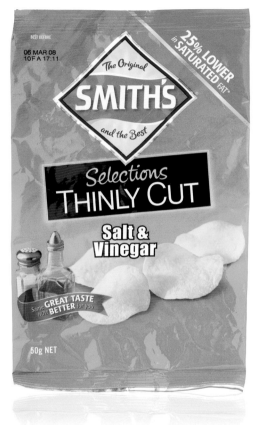

6. SALT & VINEGAR
Colour coding differs from country to country.
On Australian shelves, salt & vinegar potato chips
are recognised by a purple-pink colour. Smith's is the
local brand of Pepsico, but in most other countries
the brand is called Lay's.

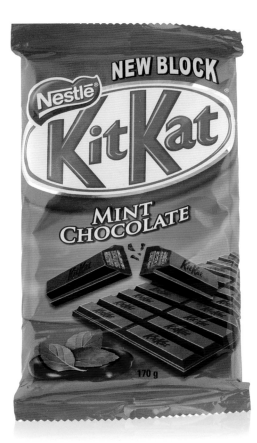

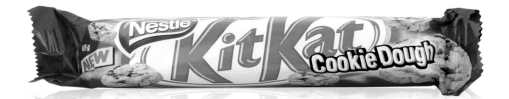

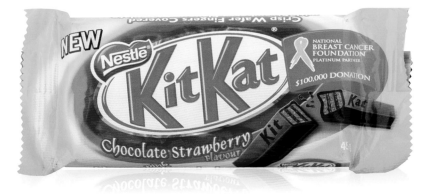

7. KITKAT BLOCK
Kitkat has a wide range of products on the Australian market. There's something for every taste, for every target group. Remarkably, the word 'NEW' is displayed on most of the wrappers.

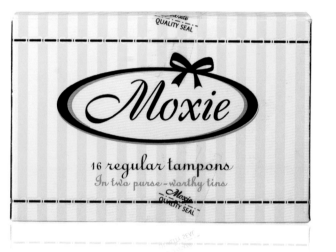

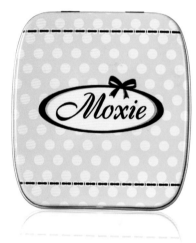

8. TAMPONS AS A FASHION ACCESSORY
The vivacious Moxie brand (see www.moxie.com.au)
produces tampons and panty liners in pretty pink
tins emblazoned with the slogan: 'Spoil yourself'.

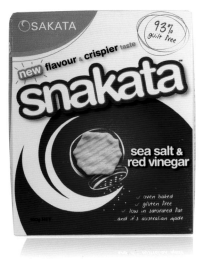

9. JAPANESE SNACKS
The Japanese roots of Sakata are clearly reflected in its logo. But not only are Snakata rice snacks entirely 'Australian made', they are also '93% guilt free'. The branding differs vastly from one product to the next.

10. FIGHTING THE FLAB
WeightWatchers products all share the same blue packaging and, above all, a lack of taste.

11. SILLY SWEETS

Allen's sweets are made by Nestlé, but this endorsement is not displayed on the front of the packaging. And while Nestlé makes a sensible call for healthy nutrition and exercise on the reverse, the front is entirely focused on grabbing the attention of a young audience.

the Netherlands

NO NONSENSE DESIGN

The Netherlands is characterised by the polder landscape. An areal view shows how the Dutch have claimed the flat land from the sea and forced it to their will. Straight lines as far as the eye can see. Form follows function. And in spring the bulb fields add colour to the landscape. It is not hard to spot a Mondriaan composition here. Apparent simplicity. But it is not about oversimplification. There is a clear indication of a concept, an idea, a thought that was given shape. And we see that reflected in the internationally renowned Dutch Design, from posters to furniture. But sadly, this tour de force is often lacking in the graphic design of commercial packaging. The Netherlands has a high density of professional agencies that specialise in packaging design. They determine, to some degree, the image of the supermarket. And we clearly notice the no-nonsense character, a result from the Calvinistic nature of the Dutch, surface everywhere. 'Act normal, that's crazy enough' is the norm. But keep it no-nonsense at a high level. Attention was clearly paid to every detail. The Dutch designer creates his own reality, of which he also pushes the limits. It is not a Dutch-only affair. As the agencies are employing more and more people from other countries. The Dutch spread out across the rest of the world and at the same time allow the rest of the world into the Netherlands. And so Dutch consumers are sometimes surprised with outstanding design, when doing the daily grocery shopping. Traditional and contemporary designs and elements alternate and merge.

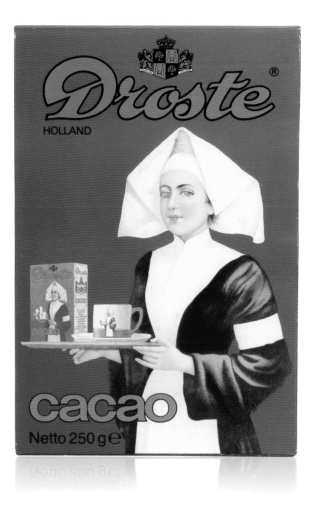

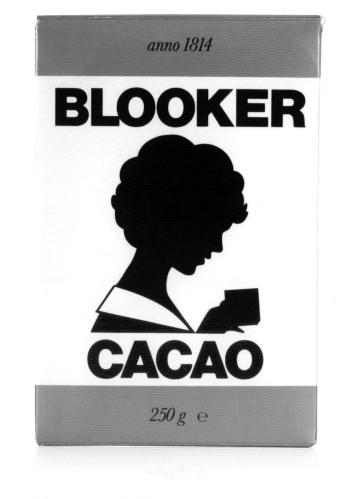

1. THE DROSTE EFFECT

Around 1900, Mr. Droste added the image of a nurse to his tins of cocoa powder, to convey the product's health benefits. In the early days even with the Red Cross, which are worth a lot of money nowadays. The nurse enters the room with a tray of Droste, which led to the Droste effect. Blooker is an even older brand. It has been in existence since 1814 and has been taken over by the Rademaker firm.

115

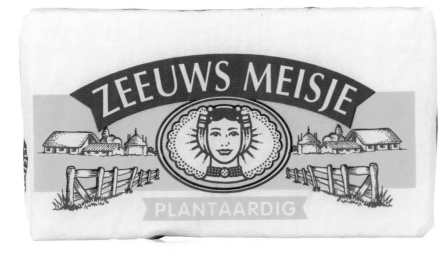

2. ZEELAND FRUGALITY

The woman from the province of Zeeland symbolises the Dutch penchant for cleanliness, diligence and, above all, frugality. Unilever has reintroduced the famous 'Zeeuws meisje' margarine brand. The CSM syrup, based on the same theme, is an example of age-old Dutch design.

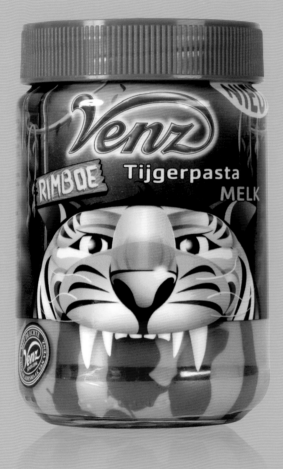

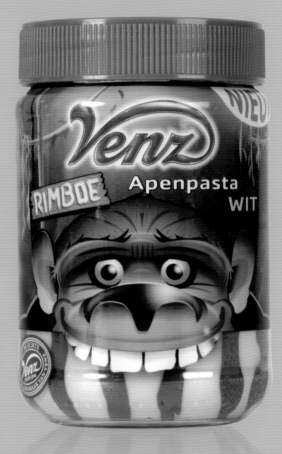

3. JUNGLE SPREAD

Venz manufactures products like duo-coloured
chocolate spread. Nothing unique about that. But
this packaging shows how the product itself can
form part of a highly distinctive packaging concept.
Children go ape for it.

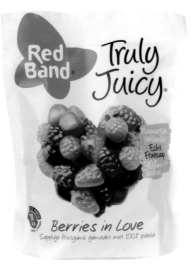
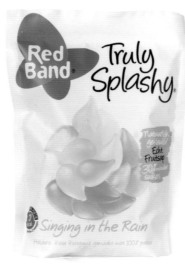
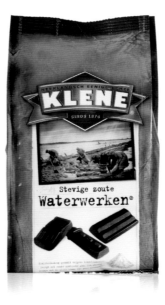
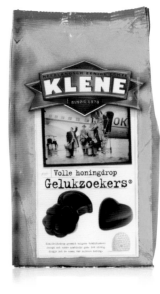

4. SWEETS ARE HEALTHY?!

RedBand has introduced an unusual line of sweets. The white packaging, the mouth-watering pictures of the sweets, the names Truly Juicy and Truly Splashy and claims like 'made with 100% passion and 30% less sugar' suggest a rather healthy type of sweet.

5. AUTHENTICITY

Johannes Coenrades Klene started making liquorice, a typically Dutch product, in 1876. The tale of other pioneers are reinforced in the liquorice shapes, the names, the imagery around the theme and the pouches reminiscent of old paper bags.
Design Agency SOGOOD won a Golden Effie and silver DBA Design Effectiveness Award for the entire Klene range.

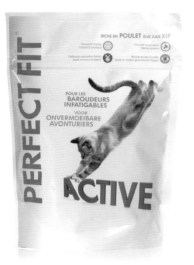

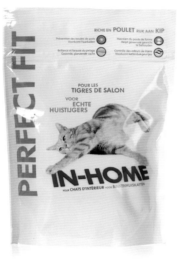

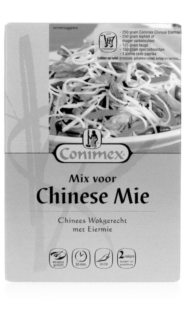

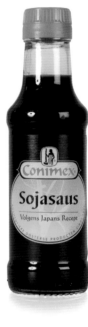

6. PERFECT CAT

The Mars brand Perfect Fit reveals nothing about the ingredients or contents on the packaging. Nor does it show a standard cat. The chicken flavour is offered in two varieties, one for the indoor cat and another for the outdoor cat. For the one claiming that the cat food 'prevents hairballs and cat box odours' and for the other recommending it 'for a strong immune system and strong muscles'.

7. ORIENTAL CUISINE

The Dutch love Indonesian food; a legacy of colonial times. Conimex, which has been taken over by the Unilever concern, has responded to this and has since expanded its field to include Oriental ingredients like Japanese soy sauce and Chinese mie noodles. While maintaining its characteristic yellow packaging.

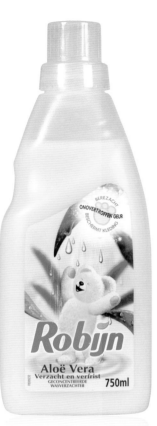
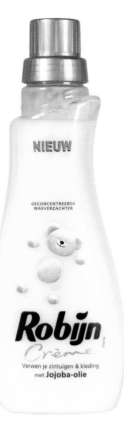
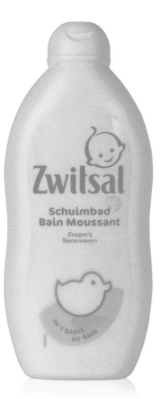
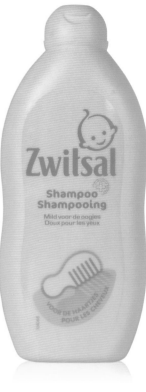

8. PLAYFUL BEAR

Robijn, Unilever's fabric softener, has had the cuddly toy bear as advertising mascot since the early years. Nowadays the bear also comes to life on the packaging in all sorts of positions and situations.

9. SOFT YELLOW

Zwitsal, SaraLee's line of baby products, has been using the colour yellow since time immemorial. The product quality and application are communicated in a friendly manner.

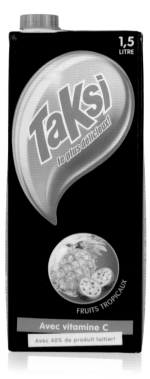
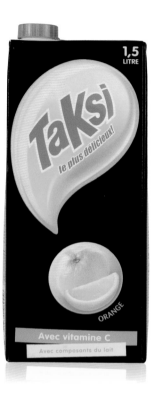
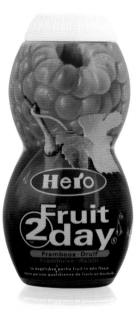
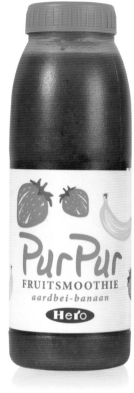

10. BLACK GOLD?
Taksi is produced by FrieslandFoods from the by-product whey. The result is a relatively cheap children's beverage with striking packaging. But does it say anything about what you can expect?

11. PURE FRUIT
Hero's innovative packaging for Fruit-2-Day suggests that it contains nothing but a combination of two fruits. But the list of ingredients argues otherwise. Perhaps Hero's less striking PurPur smoothie then? Sadly, this also turns out to be blended with apple juice.

12. SHELF APPEAL

Verkade, founded in 1886, is the local Dutch biscuit
brand of United Biscuits. Rob Verhaart of design
agency SOGOOD created the band with a repetitive
logo on the packaging to ensure that the products
have outstanding shelf appeal.

13. AS DUTCH AS CAN BE

Unox, also part of Unilever, is quintessentially Dutch
brand that is known for its 'rookworsten' (smoked
sausage) traditionally eaten with hotchpotch.
Not surprisingly, the nourishing soups are popular.
For some time now also available in pouches in addi-
tion to the canned variety. This created an enormous
sales boost.

14. THE HOUSE BRAND

Albert Heijn is the Netherlands' largest supermarket
chain. Its own AH brand consists of three lines:
standard, organic and excellent. Rather clever to
be able to offer olive three times through such a
structure. To each his own.

Belgium

TWO CULTURES IN ONE SMALL KINGDOM

What we know as Belgium today used to be a mere buffer area between the Netherlands and France. The current Kingdom of Belgium only came into existence in 1830, making it a very young nation. Despite its motto of 'unity yields strength' there's little sign of such unity. Belgium is a country divided. The discord between Wallonia in the south and Flanders in the north is deeply rooted. And it's about more than mere linguistic or economic differences. It's mainly an issue of culture. That does not alter the fact that typically Flemish products also contain French text and those from Wallonia, Flemish, i.e. Dutch, text. Bilingual packaging is required by law. Never mind the German speaking minority. The products all sit side by side on the supermarket shelves. The Delhaize supermarket in Antwerp has however created a separate aisle for its

Jewish community and a Halal section for its Muslims. And in Brussels the range is entirely different. Brussels is the capital of not only Flanders and Belgium, but Europe as well. A large international community has settled here. The national borders with the Netherlands might be disappearing, but visit a supermarket and you'll know you're not in the Netherlands. The Belgians love good food and their approach to it is truly epicurean. Supermarkets stock a wide range of luxury products and fresh produce. Typically Belgian products, like the famous beers, make up a big part of the own Belgian character. Belgian authenticity is reflected across many sections of the supermarket. And the Belgian chef, whether Flemish or Wallonian, is truly spoilt for choice. There's no denying a certain sense of national pride.

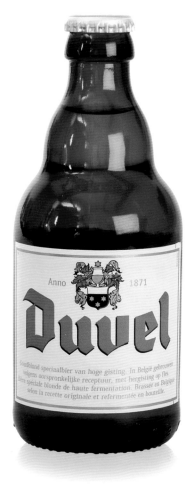
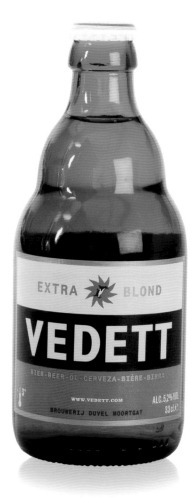
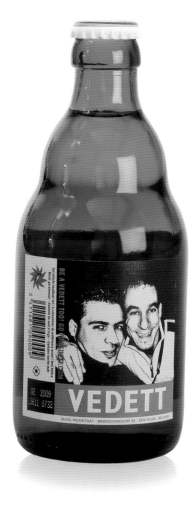

1. YOUNG AND OLD

Duvel since 1871. The label of Vedett, also produced by Duvel, has a retro look.

The website www.vedett.com lets you upload a photo and win the chance of having your portrait appear on the reverse: become a Vedett.

Delhaize's house brand, 365, displays no more than the bare product. An approach that can look cheap, but can also make for rather attractive packaging.

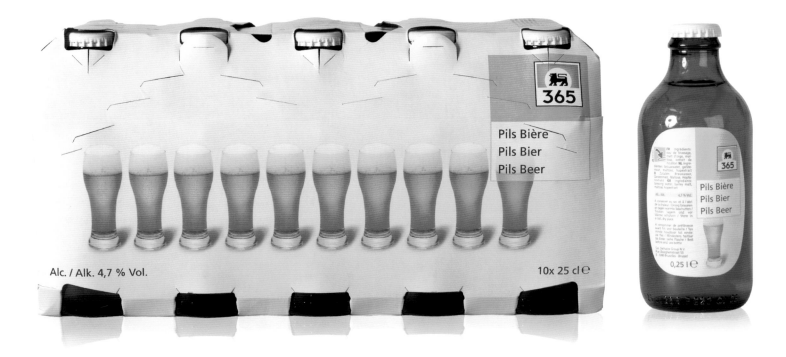

365

Pils Bière
Pils Bier
Pils Beer

Alc. / Alk. 4,7 % Vol.

10x 25 cl ℮

0,25 l ℮

Pils Bière
Pils Bier
Pils Beer

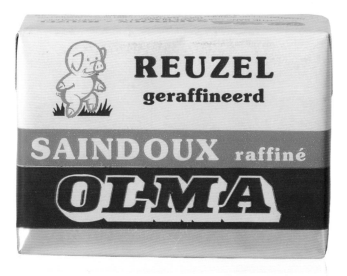

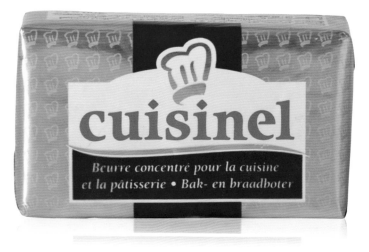

3. GREASY INGREDIENTS
Butter is stocked in the fridges and lard on the regular shelves. Both brands present their product as a basic cooking ingredient.

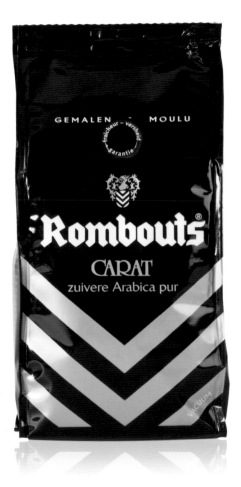

4. TRADITIONAL COFFEE

Frans Rombouts started roasting coffee beans in Antwerp in 1896. Today this family firm is purveyor to the Royal Household. 'Belgian mark of quality' it states on the side of the packaging.

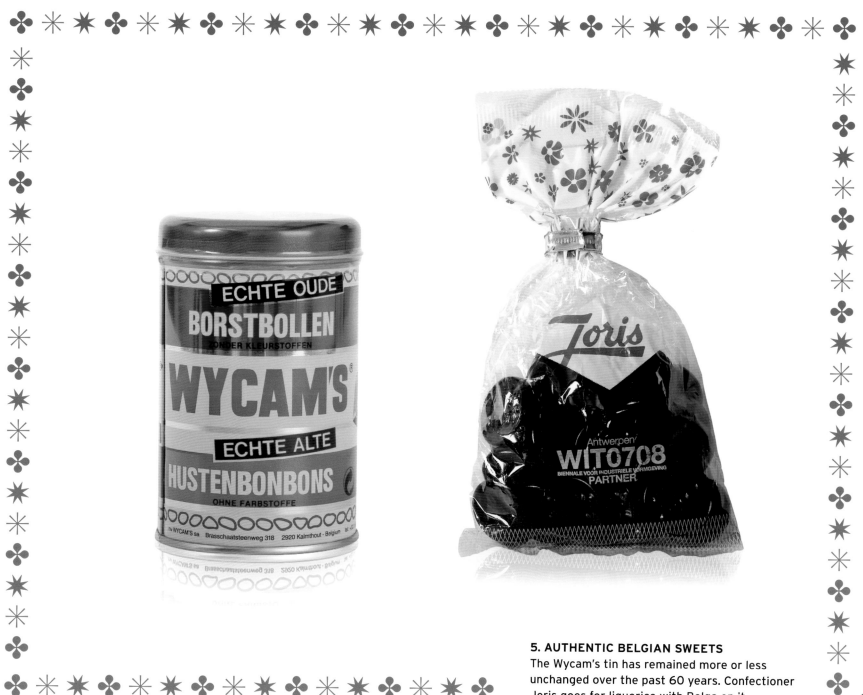

5. AUTHENTIC BELGIAN SWEETS
The Wycam's tin has remained more or less unchanged over the past 60 years. Confectioner Joris goes for liquorice with Belga on it.

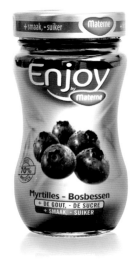

6. NOSTALGIA OR RATHER NOT?

Materne is number one on the Belgian jam market. The company takes a different approach to different target groups, depending on what consumers look for in a bilberry jam.

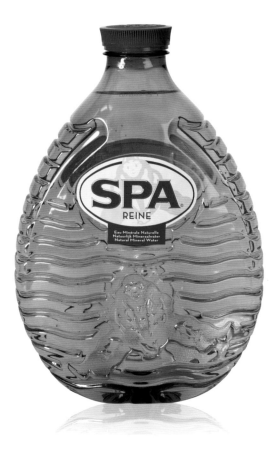

7. THE SOURCE

No brand name has become as synonymous with the product as Spa. The English word 'spa', which means mineral water or bathing place, is directly derived from the Belgian Spa. The water has been bottled here since 1583. Now available in a wide range of shapes and sizes.

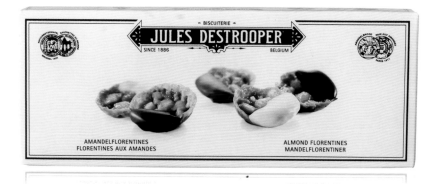

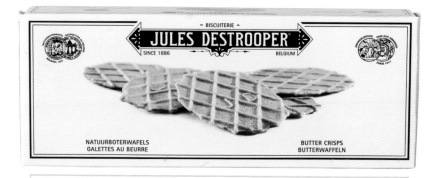

8. A LITTLE BITE OF HAPPINESS
The fourth generation of Destroopers still use traditional recipes for their luxury teatime biscuits. Nowadays, this successful Flemish venture is even finding its way to many export countries. The packaging stands out among the competitors' products, all vying for attention on the shelves.

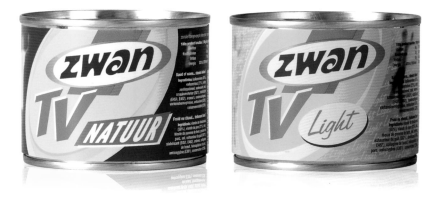

9. A TIN OF TV
These tins of the Unilever-owned Zwan brand display the compulsory list of ingredients, but nowhere do they reveal what the actual product is.

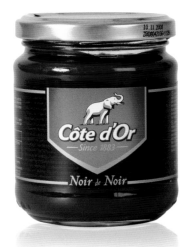

10. BELGIAN CHOCOLATE

The Gold Coast, today's Ghana, used to be a British colony on the west coast of Africa. It was from this region that the Belgian Charles Neuhaus imported his cocoa beans, and that is why his chocolate has been called Cote d'Or since 1883. In 1906 the elephant became the brand image, inspired by a local postage stamp. A true eye-catcher found in many grocery sections.

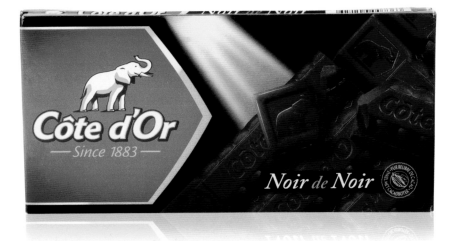

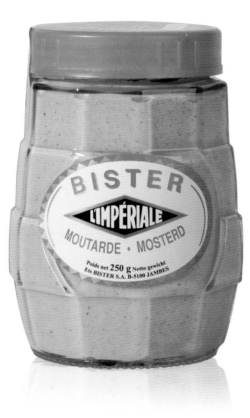

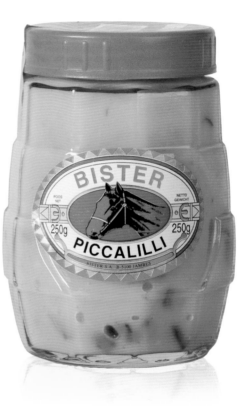

11. SMALL BUT BEAUTIFUL
The product range of the small family firm Bister
is rather limited. The mustard and piccalilli are
considered classics.

COSTARICA

TROPICAL FRUIT WITH AN UNEXPECTED TWIST

The Burt Bacharach song 'Do you know the way to San José' is a popular one, referring to a town in California. But there's another, older place of the same name: Costa Rica's capital, which was founded in 1738. The Republic of Costa Rica is a Central American state located on the neck of land between North and South America. These two parts have always experience a lot of traffic between them. Costa Rica is flanked by the Caribbean Sea on the east and the Pacific Ocean on the west. The country was colonised by the Spaniards. Costa Rica literally means 'rich coast'. Export and tourism have turned modern-day Costa Rica one of the wealthiest Latin American countries, earning it the nickname 'the Switzerland of Central America'. Costa Ricans, also called Ticos, are proud of their country, which has not had a military force since 1948, when it was abolished following the country's civil war victory. Ticos are a peace-loving people who will avoid conflict wherever possible. Their motto and customary greeting is 'pura vida', which means 'pure life' and embodies an easy way of living.

Compared to its neighbouring countries, Costa Rica has a high standard of living, good education and, in particular, beautiful nature areas. The country has more than 150 nature reserves and its Ecotourism is booming as a result. Because the country attracts so many tourists, the larger venues offer a wide variety of food. Traditional Costa Rican cuisine is simple. Most dishes consist of rice with beans and chicken or fish. Fruit is available in abundance and fresh fruit can be found everywhere. Pawpaws, pineapples, guavas, coconuts and bananas are the most popular fruits and supermarket shelves are richly filled with drinks, grooming products, sweets and jam based on these fruits.

1. LOCAL JAM

Ujarras is a local brand that produces jams, marmalades and other fruit delicacies. In Costa Rica, jams tend to be packaged in plastic tubs rather than glass jars. The design is simple and typical of this brand.

2. GOOD FOR THE FIGURE?

Deligurt by Dos Pinos is a drinking yoghurt with fruit and added probiotics. Undoubtedly good for the digestive system, as is also suggested by the shape of the bottle.

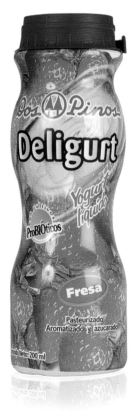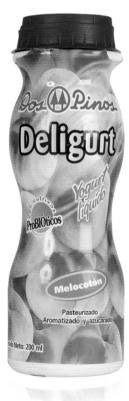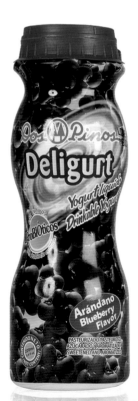

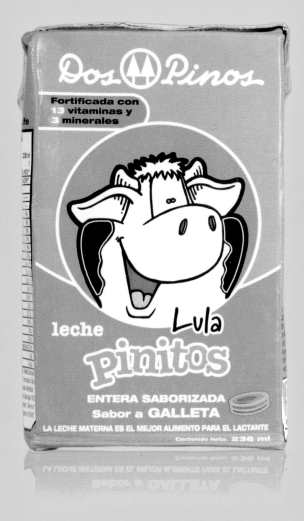

3. MERRY MILK
Dos Pinos is Costa Rica's best-selling diary label.
The company produces not only dairy products
but also fruit juices. Its long-life milk has a
cheerful appearance.

4. CHICKEN GALORE
Chicken is a popular meat in Costa Rica. The shelves are crammed with sauces, herbs and mixes for chicken. Much of the shelf space is dominated by global brand Maggi.

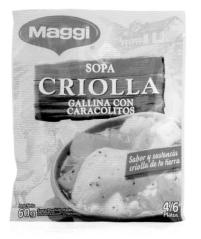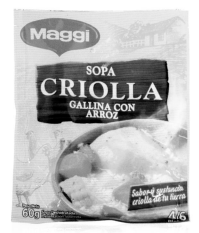

5. FRUIT-FLAVOURED JELLY?
The Kraft-owned Royal brand produces fruit-flavoured jellies that actually contain little of the real thing. To compensate, extra vitamin C has been added for a marginally healthier dessert.

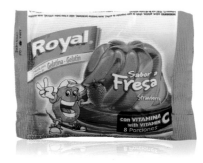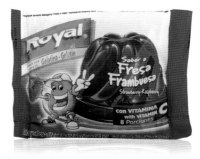

6. SNACKS
Jack's is a major local brand that manufactures products such as cocktail biscuits, breakfast cereals and biscuits. The packaging displays few label-specific components other than the logo.

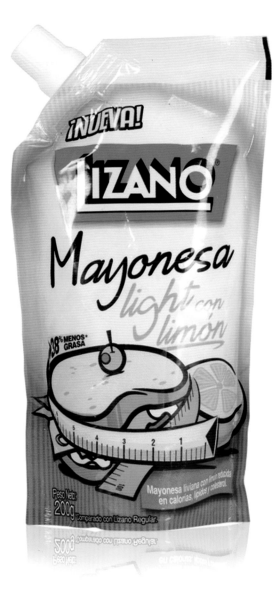

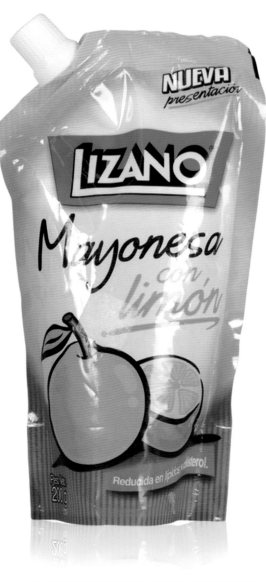

7. CONTEMPORARY STAND-UP POUCH
Lizano was established in 1920 and later acquired by Unilever. The firm originally produced only Tabasco sauce, but has since expanded its range to include salsas and mayonnaise. The mayonnaise is often packaged in contemporary stand-up pouches.

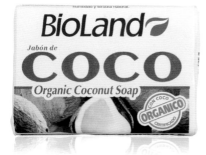

8. ORGANICALLY SOUND
Bioland is one of Costa Rica's largest organic brands. It produces not only foodstuffs, but also dietary supplements and grooming products like organic coconut soap.

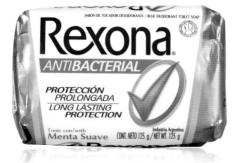

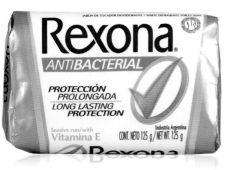

9. WASH THOSE HANDS!
Is it deodorant? Is it soap? In Europe, Rexona is associated with deodorant, but in Costa Rica it is simply soap. Which, to be fair, also fights body odours.

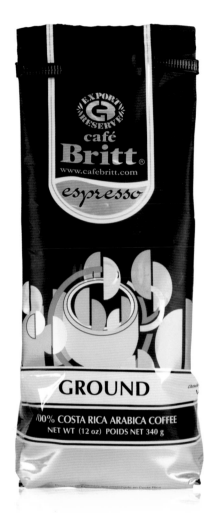
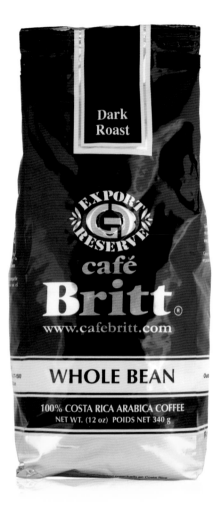

10. AND THEN THERE IS COFFEE
Café Britt is a luxury coffee brand that is actually only intended for export. You are more likely to find this coffee at airports than at supermarkets. The design can be considered Western and extravagant, compared with the local brands.

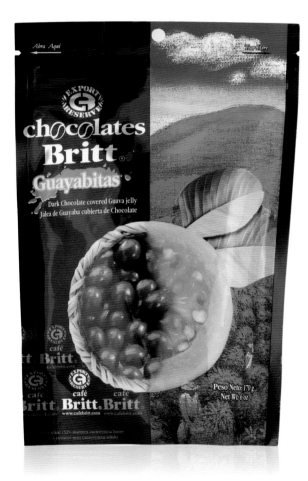

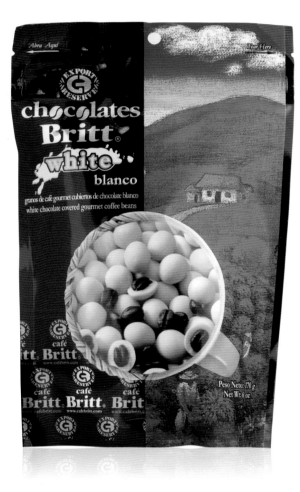

11. SNACKING ON CHOCOLATE-COFFEE COMBO

Both coffee and guavas are Costa Rican products. Tropical fruits, in particular, are a popular ingredient in sweets. Café Britt uses both coffee beans and guava bits for its gourmet chocolate balls.

FAMILY TRADITION

With a population of some 80 million, post-unification Germany is the largest of the European Union countries by far. It also boasts a rock solid economy, with a gross domestic product of almost EUR 3,000 billion. The large internal and export markets offer the Germans opportunities for great undertakings. And design plays a key role in that respect; from the automotive to the graphic sector. In 1919, the architect Walter Gropius founded the Bauhaus Design School in Weimar. There was a need to bundle the creative disciplines; a desire to achieve unity in architecture, sculpture and paint- ing. The Bauhaus soon gathered a following. The line between structure and decoration was erased. Functionality and constructivism would reign supreme. The modernisation of life was seen as paramount. Basic forms and contrasts between materials were reflected in the architecture and in consumer items. The inten- tion was for designers to assume a more prominent role in the sector and develop products that are not only aesthetically appealing, but also technologically sound. Renowned artists and theorists like Klee, Kandinsky, Itten, Breuer and Mies van der Rohe were part of it. The wall of self-importance between artists and artisans had to come down. The Bauhaus movement ended in 1933. In the same year, the National Socialists came into power and wanted nothing to do with this so-called Bolshevist bulwark of foreigners.

The question is whether the principles of the renowned Bauhaus movement are still visible today. Scarcely a trace of the 'modern' Bauhaus can be found among the array of traditional brands on the supermarket shelves. But the traditional can experience renewal, too. It seems the average German has 'zwei Seelen in seiner Brüst'. Many of the leading brands are still family businesses, each with their own tradition.

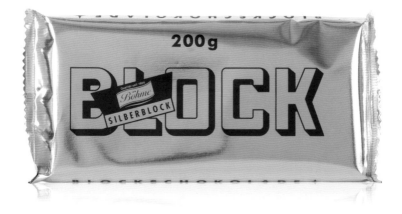

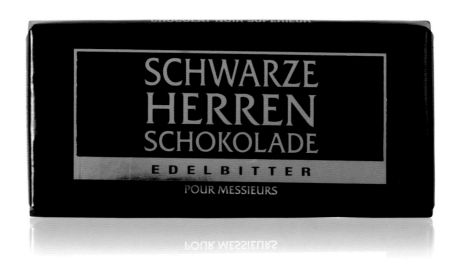

1. SILVER AND BLACK
These two concepts were probably Bauhaus
approved. Nothing that distracts from the concept:
a silver block and dark gents chocolate.

2. NO ALCOHOL
Its presentation makes this traditional grape juice look like cheap wine.

3. CHOCOLATE FAMILIES
Lindt is an originally Swiss brand and promises classic indulgence. The Ritter family, on the other hand, are 100% German and have built an empire on their unique range of Ritter Sport squares.

4. OVER THE TOP

The Reber family is another success story in the world of chocolate. Their products, variations on the same classic Mozart theme, take up almost a full metre of supermarket shelf space.

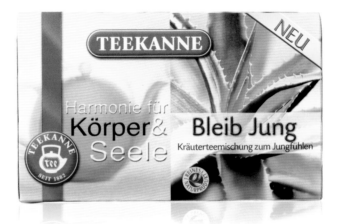
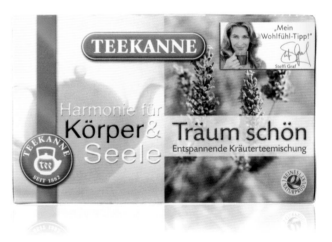

5. TEA FOR ME

After the chemist and health & beauty stores, Kneipp
has now also made its way onto the food shelves.
Without making any actual claims, the packaging
nonetheless suggests that the content is good for you.

146

6. HARMONY FOR BODY AND SOUL

This unique Teekanne tea, endorsed by Steffi Graf,
promises an instant effect on the body and soul:
Bleib Jüng (stay young) and Träum schön (sweet
dreams)!

7. ACTIVE WATER?

The oxygen-rich water Active O2, produced by Adelholzener, contains at least 50 mg of oxygen per litre. Innovative product and innovative packaging.

8. BRANDT BRAND
A little girl's face has been gracing the Brandt logo for decades. The image is revamped every few years, but the familiar child's face always ensures that new products are instantly recognisable.

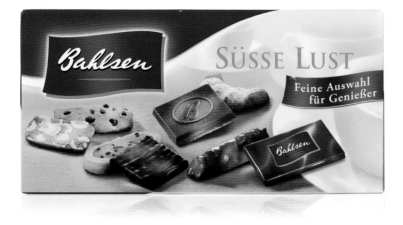

9. FEAST YOUR EYES
The biscuit shelves are clearly dominated by Bahlsen. Its packaging designs stand out, thanks to design consistency and exceptional photography and printing quality.

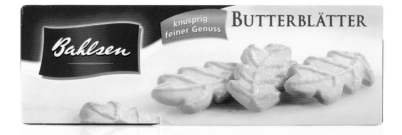

10. SUGAR VARIATION

The Kölner brand supplies the German market with a
limited number of classic sugar products. The brand
name is maintained for purely historical reasons.
All other Pfeifer & Langen products are distributed
under the European brand name Diamant, which
is also used for all new products. The Diamant and
Kölner brands share the same logo and distinctive
packaging.

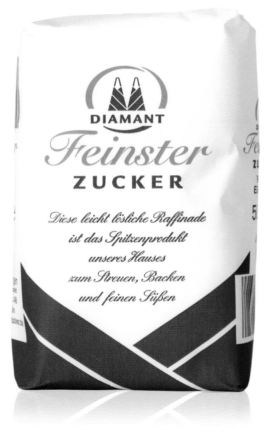

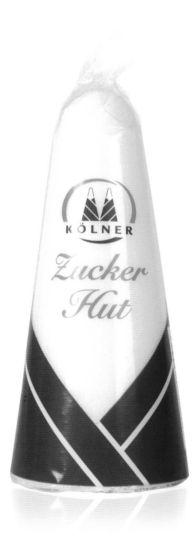

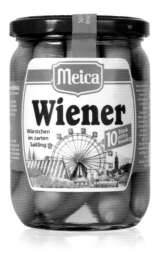
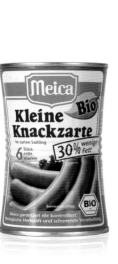

11. GERMAN SAUSAGES

German shops probably boast some of the world's largest sausage sections. Meica produces a range of Deutschländer and Frankfurter sausages. The sausages containing 30% less fat are cleverly packaged in a slim-waisted can.

12. INNOVATIVE PACKAGING

Nestlé-owned Maggi has broken with standard packaging shapes. The new shape adds an extra dimension to the experience.

13. SPICY

Fuchs markets herbs in various shapes and sizes. The packaging strikes a subtle balance between simplicity and decoration.

14. CLEAN!

Kaiser Natron is for all purpose: drinking, bathing and cleaning. Dr. Oetker however recommends that his product be used specifically in the kitchen.

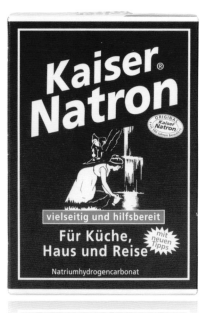

ICELAND

EMERGING YOUNG ENERGY

Iceland is one of the most developed societies in the world, having ranked first on the United Nations' Human Development Index. This is perhaps due to the fact that this small country has a population of only 300,000. The country only gained independence midway through the 19th century. It is a geologically active country whose landscape is shaped by the many volcanoes and geysers. One of the most famous geysers is called Geysir, which is also where the English word comes from.

Well into the 20th century, raw production still dominated the Icelandic economy and a simple consumer society exported practically nothing but fishing products, while almost all consumer goods were imported. Combined with increased exports of both goods and services by Icelandic companies, the understanding of the importance of innovation, branding and design was growing rapidly. As the role of design in Icelandic business expanded quickly during recent decades, the design sector grew accordingly, with 90% operating from the capital of Reykjavík. As late as the 1950s, the Icelandic language had no particular word for design, which is nowadays the word 'hönnun'. Through the years, Icelanders have benefitted from the reputation of the neighbouring Scandinavian design and often participated in Scandinavian design exhibitions. On the other hand, there are also many strong contrasts. Icelanders could be seen as the adolescent in the group: full of hormones and fighting for independence and an own identity. The best word to describe their design is 'new energy', a creative power in design, a certain enthusiasm and boldness. Icelandic design culture is brimming with energy that's just waiting to be unleashed. Not unlike a geyser.

1. FRESH BREATH
The Nói Síríus firm was established in 1920 and is Iceland's largest sweets manufacturer. OPAL guarantees fresh breath. The design looks decidedly Finnish.

2. OLD AND NEW
Both modern and dated packaging designs of Iceland's producer Goa can be found on the shelves.

3. NEW CHOCOLATE
The same manufacturer also produces this contemporary variety of chocolate bars, with colourful packaging and the flavours depicted through clear pictures.

154

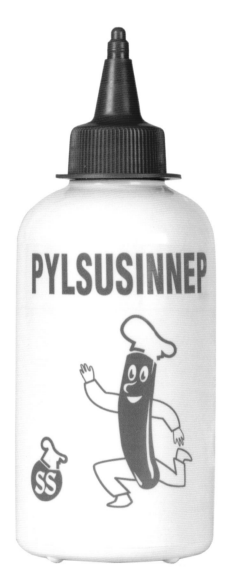

PYLSUSINNEP

4. SQUEEZE BOTTLES
Meat producer SS runs Iceland's largest abattoir.
For all that meat, they also manufacture bottled
mustard.

5. FRIENDLY MILK
Mjólkursamsalan is a producer of dairy products.
A friendly design for all ages.

6. WIDE RANGE
The same manufacturer also produces a variety
of drinks in handy bottles. The flavours are
communicated in various ways.

7. FUN FOR KIDS
For the little ones, there are sweets with a colourful,
cheeky monsters on the box.

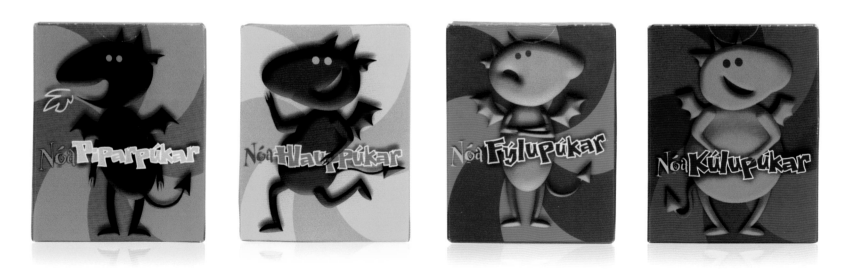

8. NOTHING BUT FRUIT JUICE?!
The power of simple design.

9. ADVENTURE
The same manufacturer Sól also owns the Avoxtur brand. Fruit juice blends for teenagers.

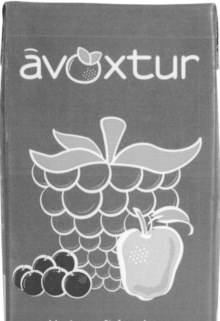

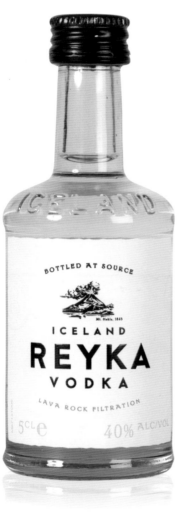

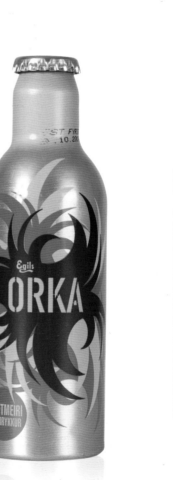

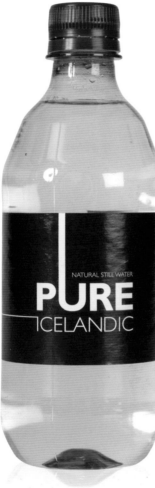

11. BLACK & WHITE
The black label of Brennivin was chosen in 1935 because it was considered necessary to have an unattractive label that would limit demand for the drink. Reyka Vodka, on the other hand, has opted for a pristine white label.

12. PURE BLUE
Pure water offers nothing more than that. But drink Egils Orka's energy drink and you're guaranteed an energy boost.

FRANCE

JOIE DE VIVRE

France's famous 'haute cuisine' originated in the 17th century. As author of works such as 'Cuisinier françois', a chef named François Pierre Varenne, is credited with publishing the first true French cookbook. Another chef, François Massialot, wrote 'Nouveau cuisinier royal et bourgeois' in 1691, during the reign of Louis XIV. His book is the first to list recipes alphabetically, perhaps a forerunner of the first culinary dictionary. Chef Marie-Antoine Carême, born in 1784, was responsible for the refinement of French cuisine. Finally, Georges Auguste Escoffier is commonly acknowledged as the central figure to the modernisation of haute cuisine in the 20th century and organising what would become the national cuisine of France. He was a French chef, restaurateur and culinary writer who popularized and updated the traditional French cooking methods. He organized his kitchens by the brigade system. He also replaced the practice of 'service à la française', i.e. serving all dishes at once, with 'service à la russe', serving each dish in the order printed on the menu. He simplified and organized the modern menu and meal structure. Escoffier's greatest contribution was the publication of 'Le Guide Culinaire' in 1903, which established the fundamentals of French cookery.

Of course, not every French person is armed with the knowledge from his book when they go shopping. But the French do grow up in a culture where food and enjoyment take centre stage. French supermarkets offer a wide range of goods for everyone, from microwave dinner fans to culinary masters. The French hypermarché has ample floor space, thanks to its location just outside the city centre. Shopping in France is true feast, especially in the culinary sense.

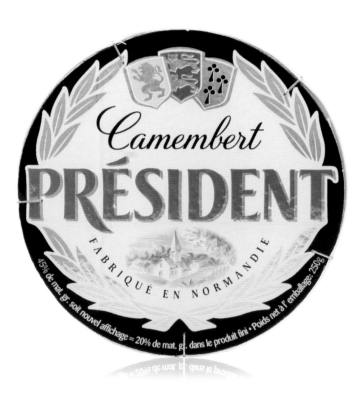

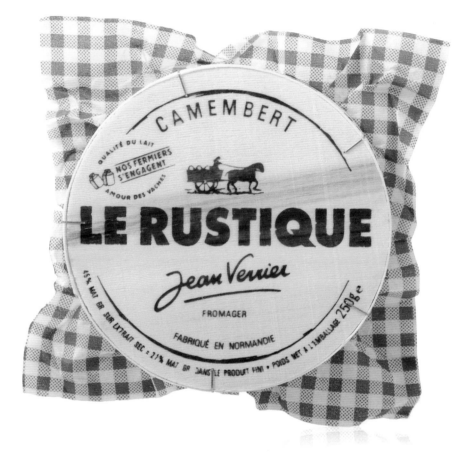

1. CAMEMBERT VARIETY
According to the Président website, its logo's colours symbolise the following: the gold represents quality and trust, the yellow stands for enjoying life and the red for passion and zeal. Le Rustique, on the other hand, doesn't need any colours to get its message across.

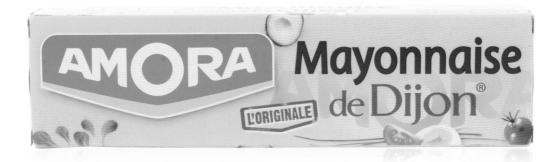

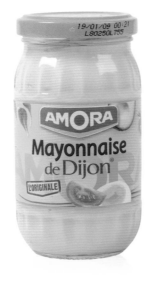

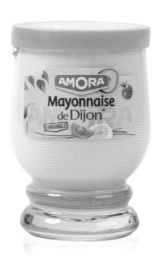

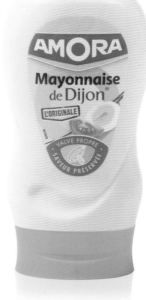

2. NEW MAYONNAISE

The Amora brand was registered in Dijon in 1919. Amora has now been taken over by Unilever. The very same mayonnaise is presented in entirely different kinds of packaging.

3. OLD MUSTARD
Antoine Maille, a distiller and vinegar maker, founded the Maison de Maille in Marseille in 1720. The company is now part of the Unilever concern. A mass product with an upmarket character.

4. SIMPLICITY
Bonne Maman has built up quite a following. The national packaging personifies simplicity. Varieties of a more exclusive nature have also become available.

5. SUGAR DADDY

The first product to see the light under the Daddy Suc label, in 1981, appeared in an eye-catching pink. Today the Sucre Union's retail brand, Daddy, manufactures a wide range of sugar products.

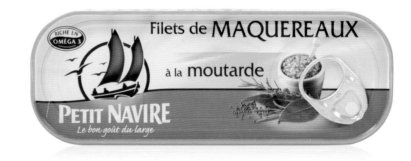

6. BLUE QUALITY
How much explanation, how much convincing do we really need?

7. FISH GALORE
Petit Navire, originally from Breton, markets a wide range of the best the sea has to offer. Its website displays an impressive overview of all its packaging designs of the past 70 years, with the same little sailboat taking pride of place.

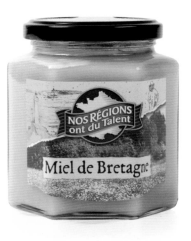

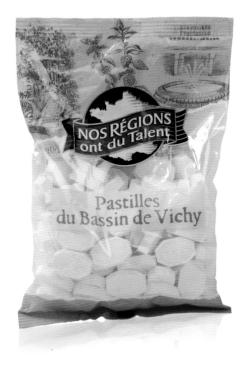

8. REGIONAL TALENT

The house brand 'Nos régions ont du talent'
can be found in many sections of the E. Leclerc
supermarkets. Each region stocks its own specific
range of local products or taste varieties that appeal
to the imagination.

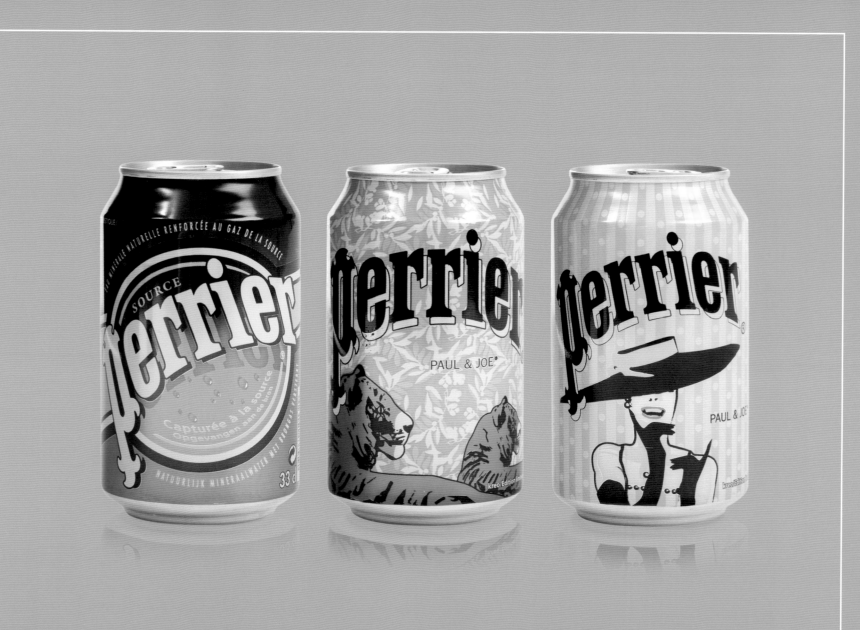

9. SPARKLING
The French mineral water brand, Perrier, named after a physician, has a rich history. The Nestlé-owned label has conquered the world. Not only its bottles are unique.

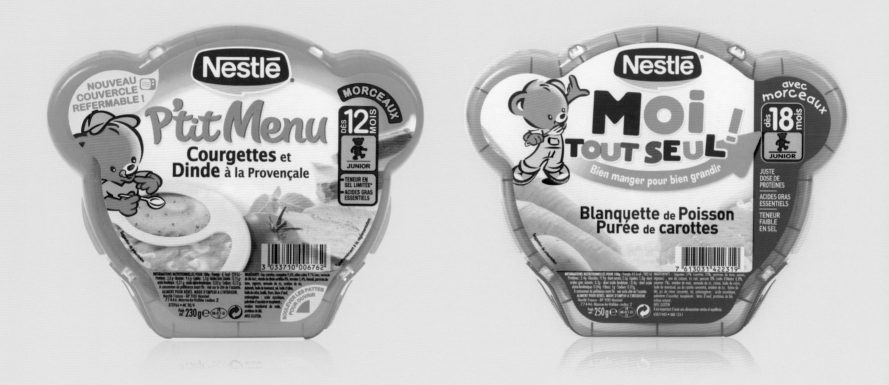

10. TEACH THEM YOUNG, TEACH THEM WELL
Nestlé produces ready-made meals for the little
ones in typically French flavours. Including a proper
'souper'. But the packaging undoubtedly produces a
mountain of waste.

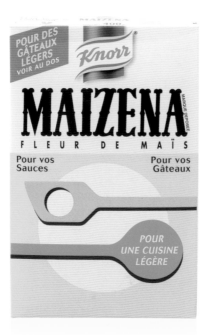

11. CORNSTARCH

The no-name brand variety is presented as an all-purpose thickener; 'pour toute la cuisine'. Whereas the Unilever-owned Maizena, endorsed by Knorr in France, is mainly recommended 'pour une cuisine légère'.

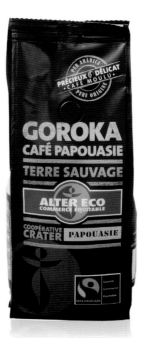

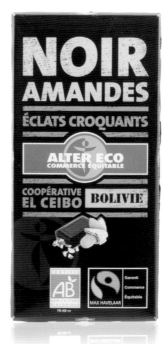

12. ALTER EGO

In 1999, Alter Eco opened a small store located in the district of Les Halles in the heart of Paris. The store sells 'commerce equitable' (fair trade) furniture, handcraft and some food products. Nowadays the company sells different products around the world.

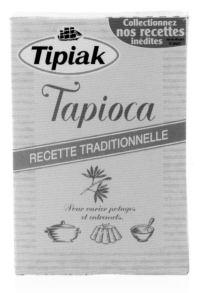

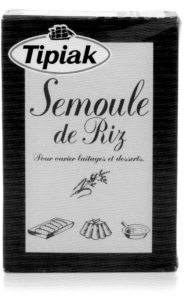

13. TYPICALLY TIPIAK
Tipiak offers a wide range of foodstuffs. But tapioca is still its most traditional product.

14. LIKEABLE
L'Oreal might dominate the cosmetics section. But soap from Marseille has been a household name for centuries and recently reintroduced.

15. ETHNO BAR
In 1720, Mathieu Teisseire created a small distillery, producing natural concentrates made of fruits and plants extracts. The French, of course, are very fond of their Sirop de Menthe Verte. For other cultures and for the sake of variation, an Ethno Bar has been added to the range.

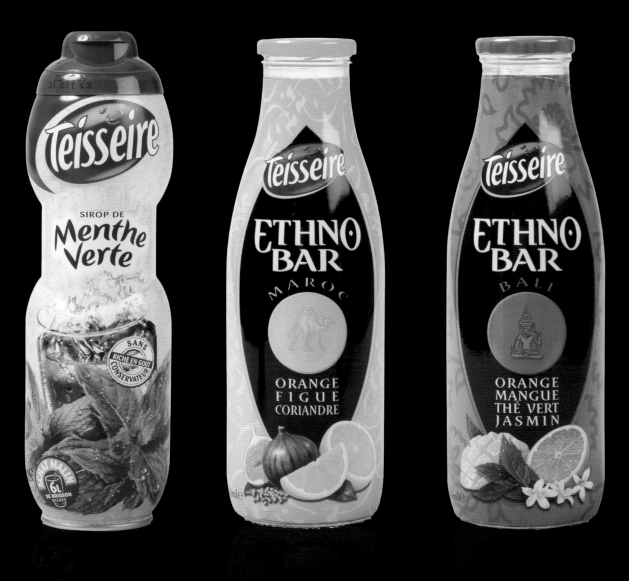

United Kingdom

TO BE OR NOT TO BE

Britain is a country of traditions. But when it comes to graphic design, it is also quite the trailblazer. Contemporary British graphic design was born in the late 1950s, the brainchild of designers such as Alan Fletcher, then a student at the Royal College of Art, who absorbed the competing influences of European modernism and American commerce. In 1962, Fletcher teamed up with Colin Forbes and American émigré Bob Gill to form Fletcher/Forbes/Gill. Their work won international acclaim and they created a model for independent practice that enterprising young designers have been following ever since. Alan Fletcher was the father figure of British graphic design. He revolutionised the practice and the business of visual communication, introducing Britain to punchy, idea-based graphics and helping transform design from a decorative extra into a key element of corporate and public life.

London is now home to hundreds of small graphic design teams, groups of designers who are characterised by their stylistic eclecticism, their lack of insularity and their connection to contemporary popular culture.

Britain's success in graphics depends on its unique art school environment and the existence of clients who understand the value of design. If both are maintained, the country's designers will play a significant role on the global scene for years to come. Before 1997, the creative sector was considered to be of only marginal importance to the UK's economic well-being. Creativity was not seen as a driving force for job creation or economic growth. Ten years later, the situation has changed completely. The Department of Culture, Media and Sport helps the creative industries thrive by raising their profile and

1. PICKLES
Classic, yes, but also very contemporary. Beauty trough simplicity, always timeless.

supporting their development. It believes that the most successful economies and societies in the 21st century will be the creative ones. Many design museums, organisations and festivals contribute to a fruitful climate for design. And the British design awards have a worldwide reputation for being the most prestigious. For the time beings, it is the Brits themselves who rake in most of the Pencils of the D&AD or the Design Effectiveness Awards. And you can see that in the supermarkets of Tesco, Waitrose or Sainsbury's. They are years ahead of their contemporaries abroad. Even the more conservative designs stand out on the shelves. What makes a packaging great? Aside from functionality, great packaging makes us want to open it up: it informs us, seduces us, speaks to us and convinces us of its value. We want to put it in our shopping trolley and take it home with us.

2. KNORR, THE ENGLISH WAY

Even Knorr has a different look in Britain. With the brand having opted for an understated look rather than the busy packaging it uses in other countries.

3. JAPANESE TEA

The British Clearspring produces both Japanese and European foodstuffs. Its Japanese tea is presented in a Japanese fashion.

4. KEEPING PACE FOR 300 YEARS

Thomas Twining started selling tea in London in 1706. The range includes classics as well as highly contemporary variants.

5. COLOURFUL CUBE

OXO cubes have been making mugs of instant broth for more than 100 years now. The colourful packaging keeps pace with the times.

6. PARTY SAUCE.
Swinging sauce for the BBQ.

7. LOOK WHAT WE FOUND!

'Convenience without compromise' it says on the website. A unique brand who takes the personal rather than tantalising approach in the presentation of its countryside finds.

8. TILDA LEGENDARY RICE

Tilda is a household name. The pre-steamed rice is packaged in an attractive stand-up pouch. They seem to have difficulty deciding where exactly to position the brand name inside the T shape.

9. PAPERFEEL

Kettle chips was one of the first to use paperfeel packaging. Setting it apart from the more factory-produced look of its competitors' foil bags. The name and design make it convincing.

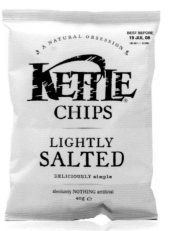
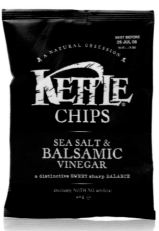

179

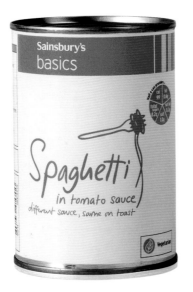
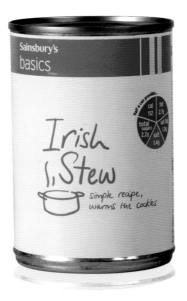

10. SAINSBURY'S BASICS
In addition to its regular private label, supermarket chain Sainsbury's also has a cheaper Basics range. These products are presented as super basic, without making them look cheap.

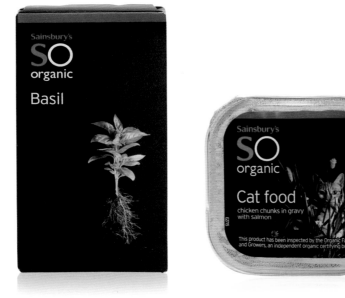

11. SO: SAINSBURY'S ORGANIC
The trademark green makes the SO range stand out in the various product departments. Even its cat food is presented in this manner.

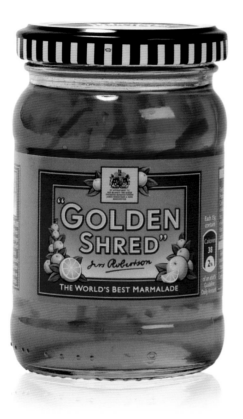
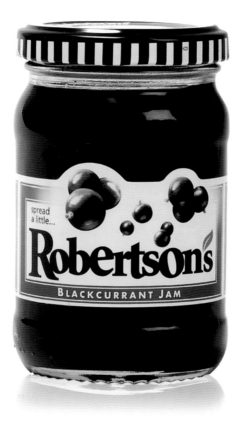
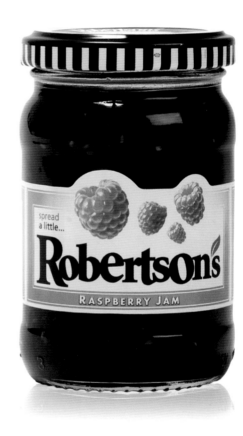

12. CLASSIC VERSUS MODERN
Scotsman Robertson claims to make "the world's best marmalade". This packaging remains classic, but other flavours have been given a contemporary edge.

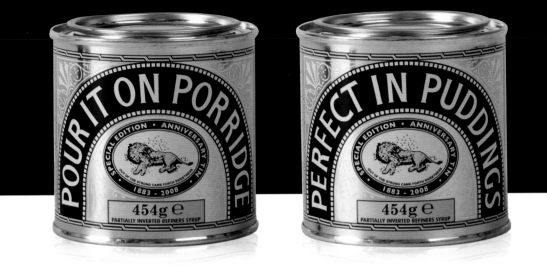

13. SPECIAL EDITION
Lyle's Golden Syrup turns 125. A milestone that's celebrated with a series of collector's tins. Same design, different text.

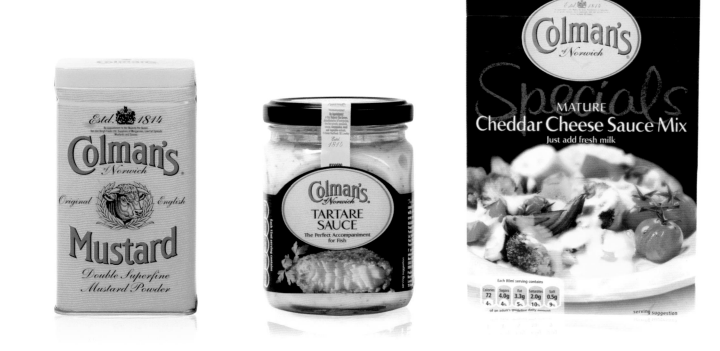

14. SINCE 1814
Colman's Mustard is a textbook example of the kind of design you shouldn't fiddle with. The core design lends itself well to line extensions.

15. INSTANT HAPPINESS
A simple idea that's both tasty and tasteful.

16. THE FOOD DOCTOR
The Food Doctor sells not only products, but books and personal advice as well. Showing the way to healthy eating and healthy living.

17. GLOBAL BRAND
Coca-Cola's image differs from country to country.
There's a striking range of Diet Coke products on
the British market.

Morocco

COLOURFUL AND SWEET

Morocco is seen as the western perimeter of the Islamic world and is therefore often called 'Maghreb', Arabic for 'the place where the sun sets'. Arabic is the predominant language, but all of the town and street names are in French as well. Berber is the third most common language and the Berbers regard themselves as the very first inhabitants of Morocco. The population has westernised in the large cities, where many women walk around without wearing the traditional headscarf. The situation is different in rural regions, where the population make a living through small-scale agriculture, cattle farming or fishing. The lifestyle here is relatively primitive: the butcher has his meat hanging in the open air, the fisherman fries his fish on an open fire and colourful characters sell their fresh mint from handcarts. The mint is used to brew the fresh mint tea which is consumed with copious amounts of sugar on a daily basis, the effects of which are clearly seen in the condition of people's teeth. A tagine, the traditional stew, often makes its appearance on the dinner table in many variations.

Since Morocco used to be a French colony, a number of French supermarket chains, which clearly reflect the local eating habits, are dotted around the larger cities. Morocco is an Islamic country, where no alcohol may actually be consumed. But the supermarkets have a separate section for alcoholic items, complete with separate checkout where long queues of waiting male shoppers form all day long. The supermarket has large fresh-food sections stocked with fish, scintillating vegetables and herbs, meat and traditional Moroccan sausages, bread and tooth-achingly sweet pastries. There are also shelves filled with nuts, tinned sardines, a vast range of coffee and tea and a lot of water, not surprisingly, since the local tap water tastes of chlorine. Moroccans love things that are sweet and colourful, whether or not through the necessary additives. And this is all explained on the packaging.

1. RICH TEA
The tea section is characterised by colourful, traditional packaging with relatively expensive boxes and printing techniques.

2. LOCAL SELECTION
The soft-drink section is dominated by international beverage brands like Coca-Cola. But a large part of the section is also taken up by this attractive and beautifully designed Moroccan soft drink in a range of different fruit flavours. Also with bilingual text, like much of the packaging.

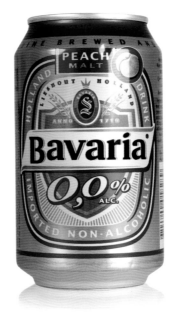

3. ALCOHOL-FREE BEER
The Dutch Bavaria brand is strongly represented with alcohol-free beer in the soft-drink section. A variety of sweet, refreshing fruit flavours in colourful standard beer cans.

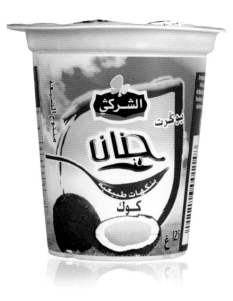

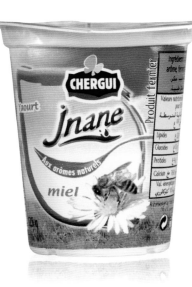

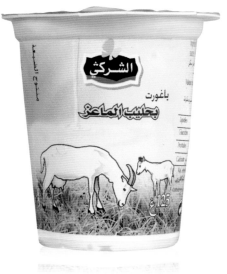

4. YOGHURT DIVERSITY
Supermarkets have a large yoghurt section that caters to all tastes. Unusual varieties include the honey and coconut flavours and goat's milk yoghurt.

189

5. DRINKING YOGHURT
Besides regular yoghurt, there is also an abundance of drinking yoghurt with the most diverse flavours on offer. These packaging designs look relatively Western.

6. CUPCAKES IN A BAG
Bags of cupcakes and a few items of sweets are displayed in lucky dip-like bins. These products are very popular. And it seems that, in this case, the brand name or design is of no importance.

7. GUNPOWDER!

Gunpowder is a type of green tea from China's Anhui Province. It's name comes from the fact that the greyish green rolled-up tea leaves resemble gunpowder pellets. This tea is used to prepare the traditional North African mint tea. The theme is further reinforced by the images of a traditional caravan or gun-slinging horseback riders.

8. NOSTALGIA AND TRADITION

It seems that a number of packaging designs have remained unchanged since the 1950s. This has helped retain the authentic character and instant recognisability of products like condensed, sterilised milk and food colouring.

9. ME TOO
Marko looks suspiciously like Mars.

10. FRENCH CONNECTION
Bimo has ties with the Danone concern and also markets product ranges like Prince.

11. ARABIC KNORR

The Knorr logo remains instantly recognisable, even in Arabic. Images of various traditional tagines are used to illustrate the different flavours. On the reverse side, an image shows the recommended consumption moment from a different culture.

Denmark

SIMPLE AND ELEGANT

The Danes are an agreeable nation. Not too many people, spread across a predominantly flat country surrounded by four seas. They are known as open, relaxed and informal. And their Royal Family have adapted accordingly. They are considered the most accessible royals, not averse to sharing, in a manner of speaking, a sidewalk café in Copenhagen with the regular folk. Copenhagen is the capital and cultural centre of Denmark. The fact that a barely 125 cm tall statue of a little mermaid perched on a rock in the Copenhagen harbour is one of the most popular tourist landmarks, attracting millions of visitors a year, is typically Danish. Copenhagen itself is a showcase of design, from the Dansk Design Museum to the many commercial designer shrines in the popular Strøget shopping street. Danish Design has its roots in the early 20th century, as a movement by various architects, furniture makers and, of course, the renowned gold and silversmith Georg Jensen. This group's product designs were based on functionality, on stripping away the frills, on using top-quality materials and applying a high level of aesthetics. The result is timeless simplicity. A style that put top designers like Arne Jacobsen and Jacob Jensen on the international map. Danish design is a combination of simplicity and elegance, according to the website of watch brand Danish Design, what's in a name. It's a combination that enabled brands like Stelton, Bang & Olufsen and Bodum to conquer the world. The question is whether this style is also reflected in Danish graphic design. A glance at the supermarket shelves gives an overall impression of accessible simplicity, class and tradition. The Danes clearly cherish their own culture.

1. CLASSIC BEER

Tuborg is purveyor to the Danish Royal Household and one of the country's oldest beers. It is currently owned by Carlsberg. Grøn Tuborg is one of the product lines. This cheerful Easter variety might look like a drink for kids, but packs a good 5.7% alcohol.

2. ELEGANT ROYAL FAMILY
Being purveyor to the Royal household doesn't mean you can't be modern. As illustrated by the striking packaging of the Magasin shop's chic private-label chocolate.

3. AUTHENTIC BOX
These authentic little boxes containing wafer-thin sheets of chocolate were introduced on the market by manufacturer Toms.

4. SWEDISH INFLUENCE
Arla Foods was established in 2000 through a merger between the Danish MD and its Swedish counterpart Arla. This secured a dominant position for the originally Swedish brand Arla in the Danish dairy section. These are tiny cups of coffee milk.

5. CONSUMER INFORMATION

The foodstuffs of Dansk Supermarked all display the Kend Varen (i.e. Know the Product) logo, signifying that the packaging provides more information than that of 'regular' products. Such information can include details on the raw materials used in the production of the article, where these raw materials came from and how they were selected and processed. Preparation and serving suggestions are also added, if space permits.

6. SIMPLE
These popular Ga-Jol pastilles with their simple, colourful packaging have been around for more than 70 years. Also the work of Danish firm Toms.

7. RACING DRIVER MUESLI

The Danish Tom Belsø used to be a racing driver in the early 1970s before setting up a company producing healthy cereals in the UK in 1977. Thanks to his Danish roots, the brand became a success in Scandinavia as well. Belsø sold his company to the British Bokomo Foods in 2005.

8. SPICY REVAMP

Karavane's herb sachets also carry the Kend Varen logo. It seems the original packaging lacked clarity, because an extra sticker was added to communicate the contents. Or was it an intentional design element?

GROFT

salt

tilsat jod

800 g

Tilsat jod efter krav fra Veterinær-
og Fødevaredirektoratet

9. SIMPLICITY IN TRADITION AND RENEWAL
Two examples of salt packaging: one, a traditional
cloth bag and the other a stark modern carton. But
both equally appealing in their simplicity.

10. HEALING SWEETS

Läkerol was founded by Adolf Ahlgren in 1909 and because of him, every candy is stamped with the letter "A". The name "Läkerol" comes from the Swedish word "läka", which means "heal".
The brand was introduced on the Danish market as early as 1910. This new variety has a more contemporary feel.

11. VARIATION

Danish brand Kims holds a 50% share in the crisp and snack market. Its packaging differs vastly from one product to the next, depending on the proposition and the target group.

205

BRAZIL

ORDEM E PROGRESSO

INTERNATIONAL AND COLOURFUL

On the sun-drenched beach at Ipanema, vendors are busy selling their wares. They don't pester you to buy, but their noisy presence ensures you can't ignore them. 'Globo' biscuits are very popular. This local brand makes a touching attempt to appear international: the packaging shows a biscuit-eating globe surrounded by international symbols, with the Italian Tower of Pisa and French Eiffel Tower on the left and the famous Sugar Loaf Mountain of Rio de Janeiro on the right. The fourth picture may prove more of a mystery to

the average globetrotter: it's the Portuguese Tower of Belém, a 16th-century fortification built in Lisbon at the mouth of the River Taag, just after the Portuguese discovery of Brazil in 1502. Globo is historically and culturally aware. You won't find any of this touching amateurism in the supermarkets of Brazil's metropolises. International brands and national brands which act as though they are international set the tone, in the colourful and exuberant manner you would expect from this South American country.

1. GLOBO INTERNATIONAL
Light savoury (green) and sweet (red) biscuits in
simple paper bags.

2. FROM NESTLÉ WITH LOVE

The Swiss brand Nestlé has a different logo for every product category. Chocolate has a heart-shaped logo. The logo can appear in different forms within the product range: even featuring a broken heart if relevant. Not a single claim appears on the packaging. The strength of a powerful brand!

3. CHILDREN'S COOKIES

The American Nabisco and the Brazilian Bauducco brands compete for the favour of mother and child. Colourful packaging with happy cookie characters screams for attention.

4. GLOBAL OR LOCAL?
The international Lay's brand is present in the Brazilian market under the brand name Elma Chips. For children there is a 30 gram bag, which is free of preservatives, colourings and with less salt. Besides crisps, they also sell nuts under the brand OPA, short for 'O Petisco Autentico', which are aimed at older customers.

5. NUTRITIOUS SNACK

The nutritious snacks produced by Nutry (what's in a name) are available in many forms. Strangely, one package is a Fruitbar from Nutry (endorsement) and the other is clearly a Nutry Fruitbar. All the more surprising because both packages bear the 'nova embalagem' claim.

6. CUP A SOUP?

Cup a Soup: as yet an unfamiliar product. The alternative, Vono, comes in single sachets complete with colourful Italian flag.

7. CLIGHT: CUP A JUICE

Lemonade also comes in single sachets. What a clever name Kraft has given to a low calorie product!

8. INTERNATIONAL VERSUS NATIONAL
Coca-Cola offers mineral water under the Aquarius label. The Brazilians themselves have Petropolis, the name of the place where, in the 19th century, the last emperor had his summer residence.

original choice

original choice

O Ministério da Saúde adverte:
EM GESTANTES, FUMAR PROVOCA
PARTOS PREMATUROS E O
NASCIMENTO DE CRIANÇAS COM
PESO ABAIXO DO NORMAL.

Disque Pare de Fumar
0800 703 7033

O Ministério da Saúde adverte:
**FUMAR CAUSA
ABORTO ESPONTÂNEO.**

Disque Pare de Fumar
0800 703 7033

9. SMOKING KILLS
Smoking is cheap in Brazil. Free has a good-looking modern pack, without annoying warnings on the front. But the back is pretty shocking: the most horrible consequences of smoking are shown in full colour.

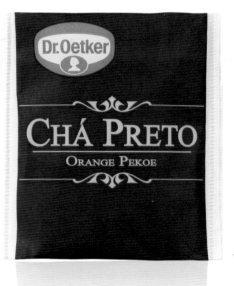

10. INTERNATIONAL OR NATIONAL?
Where Twinings offers the international brand,
Dr. Oetker is the national tea brand of Brazil. Clever
brand extension by the Germans.

11. HEALTHY SNACK
Trio is a brand that belongs to the young Brazilian company United Mills, a company that takes its corporate responsibility seriously. A surprising design for a trio of bars made from a trio of ingredients.

USA

AN AMERICAN DREAM

The United States of America was founded after the Declaration of Independence on 4 July 1776 and now consists of 50 states. Although with regard to surface area and a population of over 300 million people, the US is not the biggest country in the world, it is the biggest national economy with regard to gross domestic product.

There is no "American" ethnicity. Apart from the now relatively small Native American population, nearly all Americans or their ancestors immigrated during the past five centuries. The culture held in common by the majority of Americans is referred to as mainstream American culture, a Western culture largely derived from the traditions of Western European migrants, starting with the early English and Dutch settlers. Today, the US is one of the world's most ethnically diverse nations, the product of large-scale immigration from many countries. There is a very diverse population: thirty-one ancestry groups have more than a million members. It is a multicultural nation, home to a wide range of ethnic groups, traditions and values. There are not only big differences between the ethnic groups, but also between the states and between urban and rural areas. And all these groups have different consumption patterns. There is no greater choice than in American shops.

Americans are the heaviest television viewers in the world and the average time spent in front of the screen continues to rise, hitting five hours a day. The four major broadcasting networks are all commercial entities. The economy is based on consumption and this is what all advertisements and commercials are aimed at. Hard commercial communication also takes place on the shop floor. There is a lot of 'logo shout' packaging, but occasionally one sees brands which want to communicate in a more subtle way.

1. LOGO SHOUT!
The name Skippy, now owned by Unilever, was first used for peanut butter back in 1933. The rival Peter Pan will probably not survive long after the hype of the film.

2. MODERN DRINK
Kraft markets powder that only has to be mixed with water to create a new drink. A contemporary proposition for both adults and kids is available on the shelf.

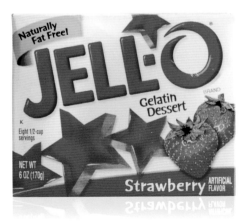

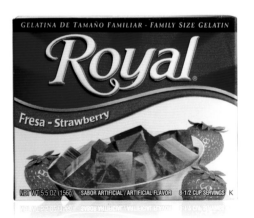

3. CLASSIC PUDDING
Jell-o gelatine pudding dates back to the end of the 19th century. Royal from Jel Sert is not as old, nor is it one of the youngest brands. It is a shame that this packaging looks so old-fashioned.

4. FOLLOW THE CATEGORY CODES

Miracle Whip Dressing from Kraft is very well known name. The private label Kroger launches Classic Whip in the same colours and goes on the attack with the text: 'Compare to Miracle Whip Dressing'.

5. CELEBRITIES

Wish-Bone is a classic dressing brand. The website of competitor Newman's Own states: 'We flourished like weeds in the garden of Wishbone'. This did them no harm at all. After 26 years, they have already donated 250 million dollars of the profit to charity. Paul Newman's motto: 'shameless exploitation in pursuit of the common good'.

6. HUMOUR SELLS

Airborne is the best-selling herbal health formula
that boosts your body's immune system.
It was created by a former second-grade school
teacher, Victoria Knight-McDowell. The packaging
is very humorous.

7. TASTES DIFFER
In America, coffee creamer with an added flavour can be added to personalise coffee.

8. CELESTIAL TEA
In 1969, a group of young entrepreneurs founded Celestial Seasonings on the principles of promoting a healthy lifestyle with tasty herbal teas, which until then had only been viewed as medicinal. The founders of Celestial Seasonings turned their cottage industry into an almost overnight success.

9. AMERICAN DREAM

In 1990, Gary started developing an energy bar, which he named after his own father Clifford. Now Clif Bar has a whole assortment. On one bar, an illustration expresses the theme, while photography does the job on another.

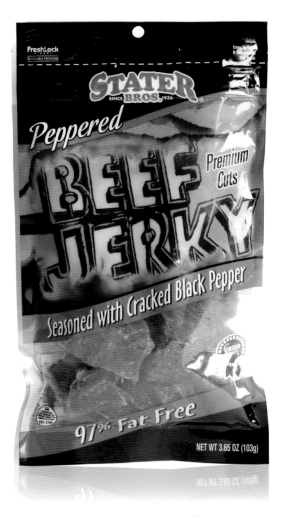

10. AMERICAN ROOTS

Pemmican, a concentrated mixture of fat and
protein used as a nutritious emergency foodstuff,
was invented by the native peoples of North
America. Now it is a brand name for the traditional
beef jerky. The private label of Stater Bros is just
communicating the name of the product.

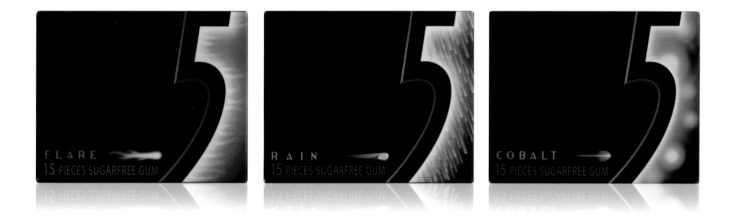

11. INNOVATION WITH CHEWING GUM
Since its foundation in 1891, the Wrigley Company
has been led by four generations of the Wrigley
family and is now the world's largest manufacturer
of chewing gum. This new chewing gum has an eye-
catching foil and comes in a chic black box.

SAME GREAT TASTE!

RICE A RONI.

Chicken & Garlic FLAVOR

Rice, vermicelli, chicken broth and garlic with other natural flavors

Net Wt. 5.9 oz (167 g)

SAME GREAT TASTE!

RICE A RONI.

Fried Rice

Delicious mix of rice, vermicelli and Asian seasonings

Net Wt. 6.2 oz (176 g)

SAME GREAT TASTE!

RICE
A
RONI.

Mexican Style

Rice and pasta with Mexican seasonings

Net Wt. 6.4 oz (181 g)

12. MULTI CULTI MIX

Rice-a-Roni was produced by an Italian family from San Francisco (see the cable car in the logo!) based on a mix of rice and macaroni. Now there is a wide assortment of products from and for all cultures.

Mokena Community
Public Library District